POSTCARD HISTORY SERIES

Fauquier County

POSTCARD HISTORY SERIES

Fauquier County

Matthew C. Benson

ARCADIA
PUBLISHING

Copyright © 2010 by Matthew C. Benson
ISBN 978-0-7385-8617-5

Published by Arcadia Publishing
Charleston SC, Chicago IL, Portsmouth NH, San Francisco CA

Printed in the United States of America

Library of Congress Control Number: 2010922710

For all general information contact Arcadia Publishing at:
Telephone 843-853-2070
Fax 843-853-0044
E-mail sales@arcadiapublishing.com
For customer service and orders:
Toll-Free 1-888-313-2665

Visit us on the Internet at www.arcadiapublishing.com

To my family and friends, and for the residents of Fauquier County.

CONTENTS

ACKNOWLEDGMENTS

I would first like to acknowledge Marta Irmen, owner of Marta von Dettingen, and business partner Christopher Duncan of 58 Main Street in Old Town Warrenton for helping me discover so many of these postcards. I would like to thank my family for helping make this possible and for giving me the art of collecting. In many ways, this book is because of the great Johnson collector's spirit. I would like to also acknowledge George and Patricia Fitch for their support during my time in Warrenton.

Today postcards act as the 1900s version of a digital picture. They show a time and place that has typically been lost and cannot be recreated. They represent a time capsule of yesteryear. In most cases, they are loved by the older generations. They are loved especially for helping people reconnect to memories of past years and what once was. For the sender, they help others see and experience their travels with a short update and simple touch.

So why is Fauquier County like it is today? Why is the piedmont so rich with traditions dating back to the Revolutionary and Civil Wars? Why do people move to this region of Virginia never to leave?

For me, it's the beautiful landscapes and stunning scenic views. Ever drive down one of Fauquier County's many country roads and been mesmerized by the beauty around you? Or take a day hike or picnic at Sky Meadows State Park, where you can overlook the rolling hills and Blue Ridge Mountains and hypothesize about the farmland surrounding the park? Or spend a lazy Saturday in one of Fauquier's small villages and historic towns? Or have you ever strolled up and down Main Street simply enjoying Old Town?

These simple acts epitomize the beauty of Fauquier County and my time in the piedmont. Because of these pleasures, I'd like to lastly acknowledge and thank all of those individuals and organizations that have helped make, and keep, Fauquier County beautiful and preserved for future generations. Especially included are the Fauquier County Historical Society, Citizens for Fauquier County, Piedmont Environmental Council, and Journey Through Hallowed Ground Partnership. We all owe you, as well as many others, a deep sense of gratitude. I would lastly like to thank the Warrenton Library for their help in putting this book together. Unless otherwise noted, all images are courtesy of the author.

INTRODUCTION

Fauquier County, Virginia, is an area of land with rich history dating back before the founding of this nation. Fauquier was created from a series of divisions of the Northern Neck counties, including Northumberland and York. Out of Northumberland, Stafford was created in 1664. From York, Lancaster County (1651–1952) was established and then Old Rappahannock in 1656. Old Rappahannock was then split into two, Essex (1692) and Richmond (1862). King George followed from Richmond in 1721 and then merged with Stafford. Prince William was established in 1721, laying the groundwork for Fauquier to be created on May 1, 1759. Fauquier County celebrated its 250th birthday with spectacular festivities on May 1, 2009. The unprecedented history of Fauquier can still be seen today, and the pride of Fauquier County residents has never gone unnoticed. Before the formal establishment of Fauquier County, the Manahoac Indians, (the name meaning "they are very merry") of the Sioux Nation lived on these lands.

Fauquier County is named after Sir Francis Fauquier, the lieutenant governor of Virginia from 1758 to 1767. Fauquier County is comprised of 422,400 acres, or 660 square miles. According to recent population estimates done in 2008, roughly 67,000 people call the county home. Over 8,000 people call the county seat, Warrenton, home. Warrenton was incorporated in 1810 and named after Gen. Joseph Warren. Two lesser-known facts are that Warrenton's first City Directory, listing 3,561 adults, was not published until July 1963. And in July 1963, the streets in Old Town Warrenton were renamed with the numbering reversed, giving way to its current system.

Fauquier County is home to three towns, Warrenton, Remington, and The Plains, and several unique villages, which include Paris, Upperville, Marshall, Calverton, Bealeton, and Catlett. Almost every major thoroughfare welcomes visitors and residents into the county with an unmistakable greeting. Fauquier County is home to over 1,220 farms on 222,000 aces. Fauquier has over 17 wineries, the fifth-largest dairy industry, and the eighth-largest cattle and fruit industries in the commonwealth. In addition these agricultural statistics, nearly 90,000 acres of land have been protected and preserved as open space for future generations to enjoy throughout Fauquier County. You might ask, "Why are these statistics mentioned?" For me, Fauquier County is about the beautiful people, places, and scenes.

In Warrenton, homes and estates such as Paradise, Britton, Jeffries, Carter, Marr, and Keith give the town its charming character. Pikes (streets) such as Winchester, Culpeper, Falmouth, and Alexandria usher people in and out of town, taking visitors and residents to Fauquier's beautiful countryside and adjourning counties. With historic names, the state highways of Routes 15, 17, 29, and 211 allow automobile passengers to easily access the interstates of 66, 81, and 95. The dramatic rise of the Washington metropolitan area during the later half of the 20th century helped give Fauquier County its current make-up, as well as determining its landscape for future use. Being only a few dozen miles from our nation's capital, with an increasingly urban population and feel, it's always amazing to come back to Fauquier or tell people where you live and see the response as though it's on the other side of the country. Fauquier is seen to many

in three parts—the north with its large country farms and estates; the center with Warrenton anchoring its people, landscape, and character; and the south with its large working farms and new developments.

Historical figures such as John S. Mosby, Turner Ashby, William "Extra Billy" Smith, and John Marshall have all called Fauquier County their home. In contrast to their predecessors, the modern-day well-known figures of Walter Chrysler, Robert Duvall, and Paul Mellon have also called Fauquier County home. The area surrounding Warrenton is known as the Mosby Heritage Area and still retains much of the landscape and many of the original historical landmarks from the past three centuries. Known by many, one person extremely important to Fauquier County is Joseph Arthur Jeffries, born in 1840 at Bellair. Without Jeffries, this book, and so many others that share Fauquier County's history, would not have been possible. Almost every community had a person who took photographs of his or her town and the surrounding area during the early 1900s. Jeffries did this for Warrenton and Fauquier County. He also owned the town pharmacy, Jeffries Pharmacy, a successful business for 31 years located near Courthouse Square. You can look closely in many of these old postcards and see his name. Besides Jeffries, Marshall historian John Gott also shared much of Fauquier County's history.

Anchoring Warrenton and Fauquier County from its earliest days to the present has been the Fauquier County Courthouse. The Fauquier County Courthouse still attracts people from all over to take its photograph. It can be said that hardly a weekend goes by that its photograph is not taken. For me, the courthouse caught my eye the first time traveling up Alexandria Pike on a warm, summer night going through the intersection with Main Street. And it still does today.

There are so many fantastic regions of the county that are uniquely Fauquier. Some of these parts include the Route 28 corridor; the Crooked Run Rural Historic District from Delaplane to Paris; Lees Ridge and Springs Roads; and the Route 50 corridor from Paris through Upperville to the Loudoun line. The list could go on for almost forever.

Although I have only lived in Fauquier County for a short time, I can't imagine my time here not affecting the rest of my life. I have learned so much while being here. I am sure we all have, even those just in for a visit. Because of this, the attempt of the book is to share the scenes and stories that these old postcards tell. So I invite you to take this journey through the book. Enjoy reading the captions and seeing the sites of Fauquier's heritage. It was a pleasure to put it together.

One

THE CONFEDERACY AND JOHN S. MOSBY

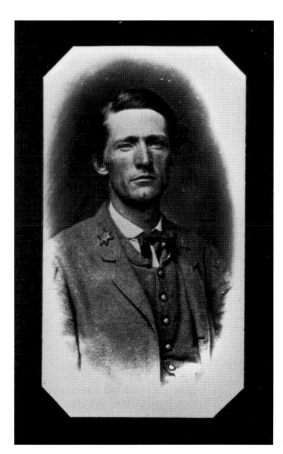

Here is a portrait of John S. Mosby. Throughout 1864 and 1865, up and down the Valley of Virginia, John S. Mosby and his men, the "hellcats on horseback," effectively harassed Grant and Sheridan. Anticipating the tactics on modern commandos, Mosby enlisted old men and young as well as farmers and foreign adventurers.

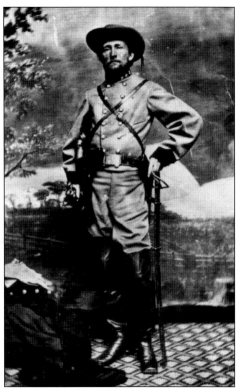

Here is John S. Mosby dressed in his military gear. Planting a cannonball in the vitals of a locomotive, Mosby cleaned a payroll train of $172,000 in Federal currency. In a battle, Custer shot four and hanged two of Mosby's men, so Mosby gave the same treatment before calling a truce. In his plumed hat and flowing cape, Mosby was a true Virginia gentleman to the last.

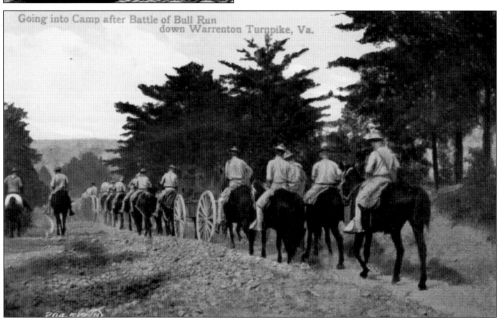

Going into Camp after Battle of Bull Run down Warrenton Turnpike, Va.

Warrenton sent nearly every eligible, able-bodied, white male in town into the Confederate army. The Warrenton rifles were commanded by Col. John Quincy Marr, the first Confederate officer killed in conflict. The Black Horse Cavalry was the most renowned Fauquier company and took part in most of the Virginia campaigns. John Scott organized it, and later Gen. William H. F. Payne and Alexander D. Payne took command of it.

The Warrenton Cemetery was created in 1836 by the Town of Warrenton and contains graves of partisan ranger Col. John S. Mosby, Capt. John Quincy Marr, and Gen. William H. F. Payne. This 25-foot high Confederate memorial was erected in 1873 and dedicated in May 1877. Gen. Wade Hampton was the orator for the dedication ceremony.

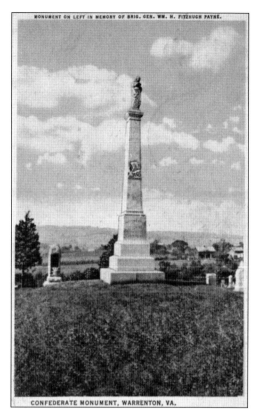

MONUMENT ON LEFT IN MEMORY OF BRIG. GEN. WM. H. FITZHUGH PAYNE.

CONFEDERATE MONUMENT, WARRENTON, VA.

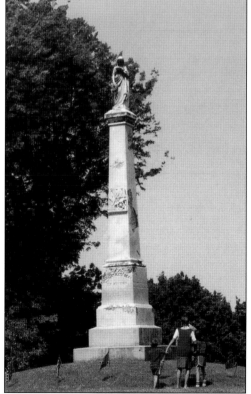

The Confederate War Memorial commemorates the 600 unknown soldiers buried at this site in the Warrenton Cemetery. Col. John S. Mosby, who took command of units from Fairfax, Fauquier, and Loudoun Counties, is buried nearby to the right. Because of Warrenton's position, it was a natural location for many deaths.

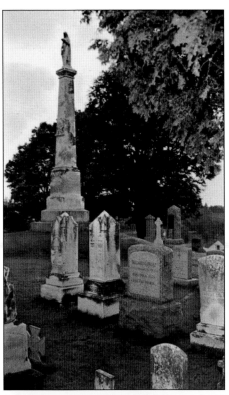

Pictured here is part of the Warrenton Cemetery near the Confederate War Memorial. A map on the caretaker's cottage identifies the location of all Confederate graves. The Warrenton Cemetery, with an address on Chestnut Street, is close to the Fauquier County Sheriff Station, which is on the corner of West Lee and Keith Streets, and Napoleon's Restaurant.

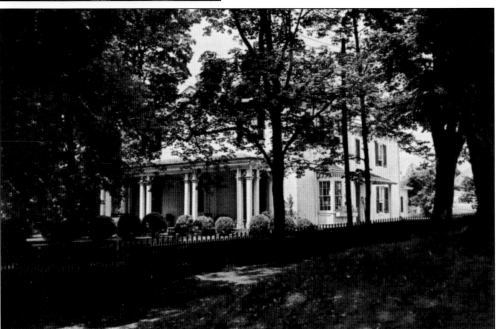

The Anderson House was built in 1854 by the Spillman family. It was once home of the famous Col. John Singleton Mosby. Mosby commanded the 43rd Battalion of Partisan Rangers and was known as the "Grey Ghost." Mosby, with fewer than 200 men, caused so much trouble in the northern part of Virginia that the Union army had to station over 14,000 soldiers to defend their supplies.

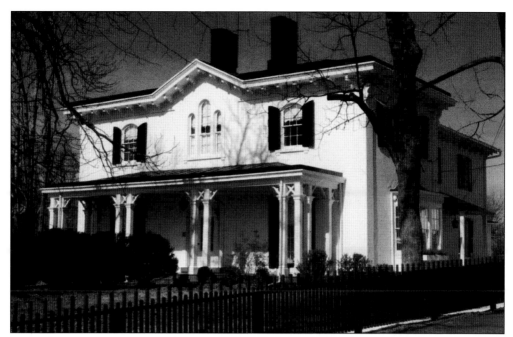

Located at 173 Main Street in Old Town Warrenton, Brentmoor is listed on the National Register of Historic Places. Two Confederate officers, Col. John S. Mosby and Gen. Eppa Hutton, owned it at different times. After the Civil War, Mosby settled down to a law practice, which was disturbed only by political squabbles and an occasional duel. Mosby even made peace with General Grant and became a welcomed visitor to the White House.

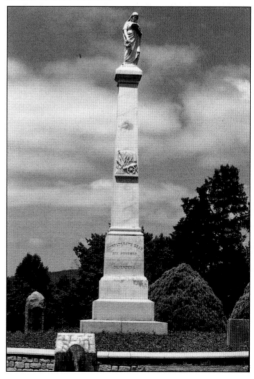

One of the roads leading to the Warrenton Cemetery and the Confederate War Memorial in Old Town is Pelham Street, named after Maj. John Pelham, CSA. Major Pelham was mortally wounded on March 17, 1863, in the skirmish at Kelly's Ford on the Rappahannock. During this battle, a drawing was done documenting the charge of Gen. Fitzhugh Lee that appeared in *The Official and Illustrated War Record* in 1898.

MOSBY'S CONFEDERACY

As an old man, Mosby was revered not only by the gray-haired partisans who had followed him in their youths but also by his former enemies. Mosby died in Washington at the age of 83 and is buried in Warrenton. He was deeply mourned by the state he had loved so well. Today Mosby country surrounds the Warrenton area and northern piedmont with the Mosby Heritage Area.

Two

MAIN STREET
WARRENTON

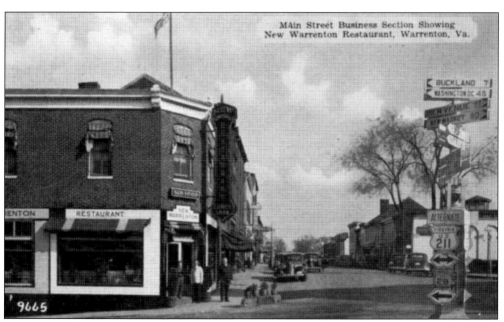

Shown here is the corner of Main Street and Alexandria Pike looking east down Main. The corner building where the New Warrenton Restaurant sits was built in 1889 as a post office that was in service until 1919. Changes have occurred to this intersection throughout the years, but its general character has remained constant.

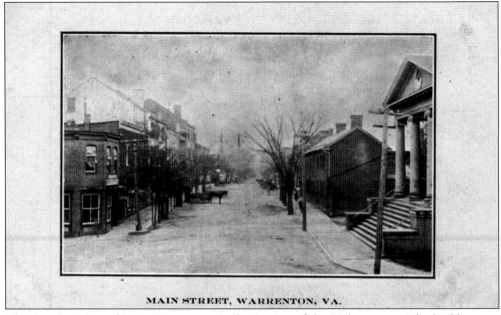

MAIN STREET, WARRENTON, VA.

This is a depiction of Main Street near the beginning of the 20th century. The buildings on the left were all built in the late 19th century. Just a few buildings down from the corner at 15 Main Street is the structure known as the Jeffries Building, built in 1847. This building served as one of the town's principal drugstores for many years.

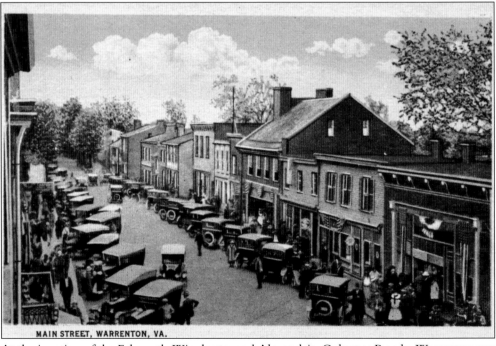

MAIN STREET, WARRENTON, VA.

At the junction of the Falmouth–Winchester and Alexandria–Culpeper Roads, Warrenton was founded a few years after the founding of Fauquier County. By the time of the Revolution, a settlement had grown up, and in 1790, the courthouse was built on its present location. Richard Henry Lee donated 71 acres of land for the county seat, including the courthouse and county jail.

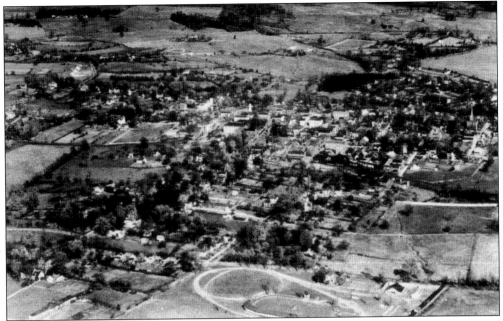

This shows an overhead picture of Warrenton, including Old Town. Warrenton Pony and Horse Grounds is near the bottom of the card, while Academy Hill is located at the top. One can make out Culpeper Street with the large trees, as well as the Baptist church and Fauquier County Courthouse on Main Street.

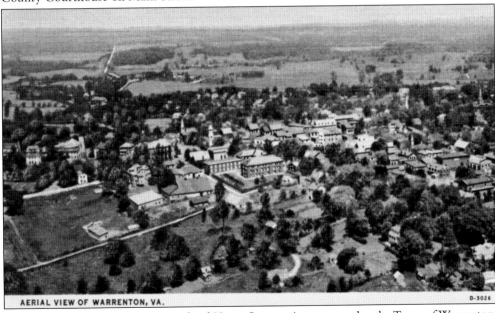

AERIAL VIEW OF WARRENTON, VA. D-3026

In 1810, the land grant given by Richard Henry Lee was incorporated as the Town of Warrenton. By 1835, the town had a population of 1,300, including three resident ministers, nine attorneys, and eight physicians. In 1853, a railroad reached the town, which then included several churches, thriving mercantile establishments, a weekly newspaper, and two schools. Today Warrenton still has a thriving Old Town with shops along Main Street. Many of the church steeples still dot the landscape from a far.

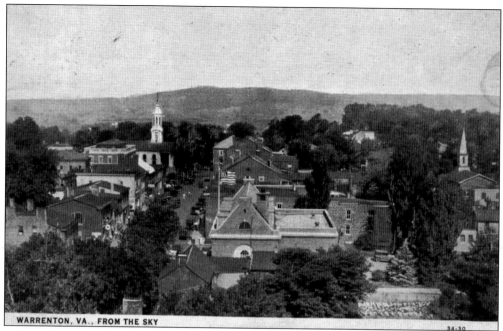

WARRENTON, VA., FROM THE SKY

In 1790, the courthouse was built at its present location, a jail was erected, and an academy was named in honor of Gen. Joseph Warren, the hero of Bunker Hill. The grant donated by Richard Henry Lee for the land to create Warrenton was officially incorporated in 1810. Today Warrenton has a population of 6,670 people and is known for the many law firms with offices in Old Town.

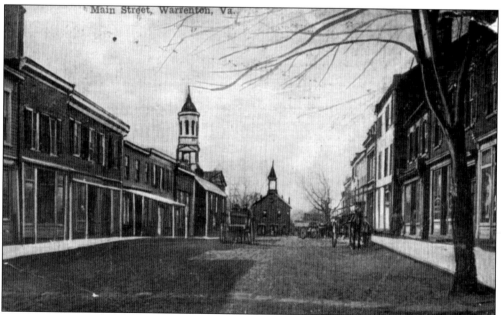

Main Street, Warrenton, Va.

This shows a picture of historic Main Street in Warrenton is looking west toward the Blue Ridge Mountains. On the left is the courthouse steeple, and horse-drawn buggies are up and down the street. Most of the buildings along Main Street were built in the late 19th century and had commercial establishments with residential apartments on the second floor.

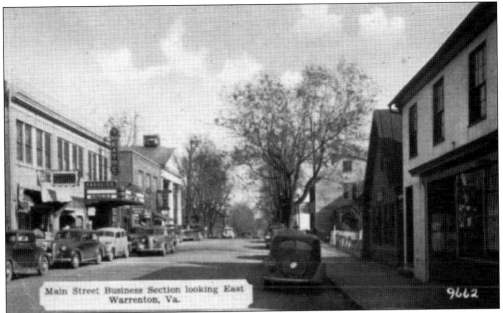

Main Street Business Section looking East
Warrenton, Va.

9662

Warrenton has long been a quaint town with shops and businesses on Main Street for country residents and townspeople to frequent. On the left, the Fauquier Theatre is currently showing *Honolulu*, which premiered in 1939. This theater was open for many years but closed officially in 1974. Today Rhoades Drug and the Main Street Grill occupy this space on Main.

Warrenton's Main Street, along with nearby picturesque streets, is included in a historic district that is listed on the National Register of Historic Places. East Main Street is home to many historic houses such as Granville, which was built around 1820. Granville was originally the home of Daniel Payne and consists of two houses joined together.

19

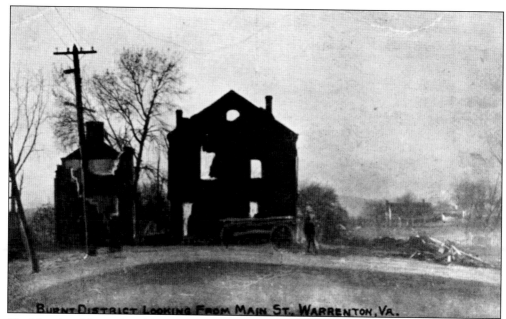

On Monday, November 22, 1909, a fire apparently started in the hayloft of Bradburn and Clatterbuck's livery stable on Seventh Street, beyond the skating rink. To stop the fire, seven houses were dynamited, including Yate's Store. In total, 26 buildings were burned, leaving 14 families homeless. For days afterwards, the people of Warrenton were in shock as they viewed the smoldering result.

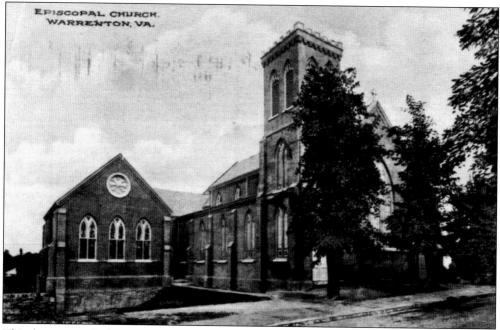

This shows an early depiction of the Episcopal church, located on Culpeper Street. Construction for the Spillman Memorial Parish House had yet to be started. This is just one of many postcards taken by town historian Joseph A. Jefferies. The Episcopal church can be seen down Culpeper Pike from the intersection of Lees Ridge and Springs Roads.

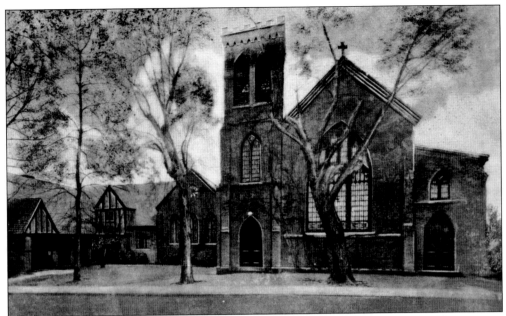

The St. James Episcopal Church was established in Warrenton in 1816. Its first building was on Alexandria Pike but it moved to its present-day location (pictured here) in 1828. Its original steeple, also pictured here, was later lost during a furious storm. Strolling down Culpeper Street on a Sunday morning, one will often see a festive atmosphere out front with lots of townspeople gathering for Sunday service.

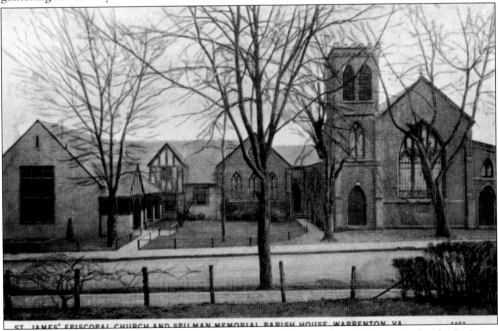

ST. JAMES' EPISCOPAL CHURCH AND SPILLMAN MEMORIAL PARISH HOUSE, WARRENTON, VA.

Shown here is a similar photograph of what people would see today while passing by the St. James Episcopal Church and Spillman Memorial Parish House on Culpeper Street. In the foreground, a fenced-in yard with old trees lining the street can be seen. This no longer exists, with Franklin Street and now one of Warrenton's municipal parking lots replacing the grass.

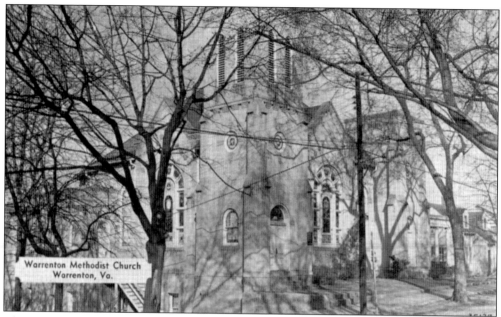

Warrenton Methodist Church
Warrenton, Va.

The Warrenton Methodist Church on the corner of Winchester Street and Diagonal Street was built in 1912, replacing the original Methodist church that was built in 1818 and located at Lee and Culpeper Streets. The first pastor of this church was Rev. George Brown. The current Warrenton Methodist church is known as the Warrenton Bible Fellowship. It sits directly across from Britton Hall.

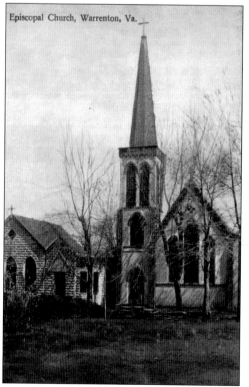

Episcopal Church, Warrenton, Va.

Here is an early picture of the Episcopal church that is now known as St. James. The steeple was lost in a storm, and the Spillman Memorial Parish House was added on. Although the landscaping has changed, much of Culpeper Street still remains today as it was in the early 1900s. For instance, almost directly across the street is the Charrington House, built around 1900 at 100 Culpeper Street.

The brick Baptist church, which replaced a wooden church, was built in 1850. During the Civil War, it served as a hospital. It can bee seen today at 123 Main Street in Old Town. Three Sunday services take place at 8:00 a.m., 9:30 a.m., and 11:00 a.m. Across the street is the Old Mill, built around 1824.

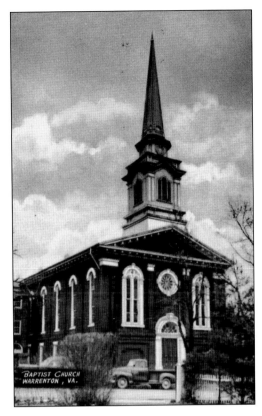

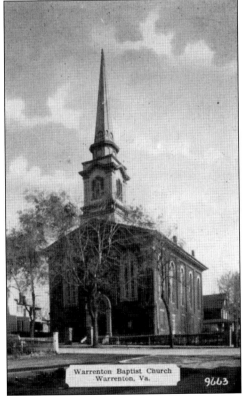

The First Baptist Church, at 39 Alexandria Pike and visible from Courthouse Square, was built in 1897 and is the oldest, African American church in Warrenton. Sunday worship begins at 11:00 a.m. To the left is the Paint Shop, on the corner of Alexandria Pike and Horner Street.

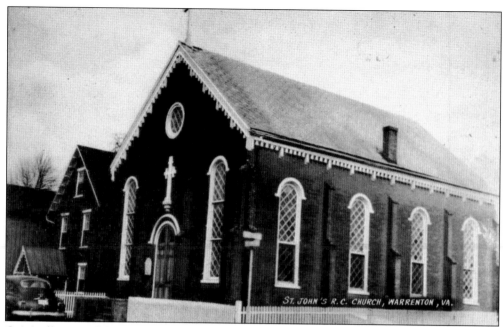

Originally part of the Diocese of Richmond, many Warrenton and Fauquier County Catholics worshipped at this St. John's Church on Lee Street before moving to a larger church on Winchester Street in 1965. It sat empty for a long period and became somewhat decrepit and uninhabitable. Today restoration is underway to bring it back to its prominence.

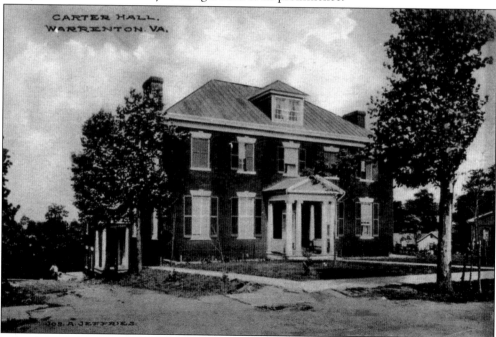

Taken by Joseph A. Jeffries, this photograph of Carter Hall shows an early view. Today the road to the left of Carter Hall still exists and takes people toward Alexandria Pike and the bypass. The trees out front and on the side can also still be seen and spectacularly bloom in the spring. To the right of Carter Hall is the Winchester House at 23 and 25 Winchester Street.

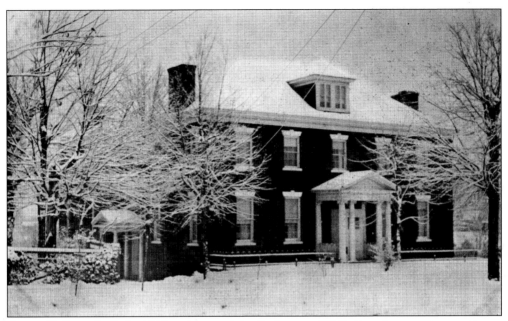

Carter Hall was built in 1819 and was originally home of U.S. Sen. Inman Horner. Carter Hall burned in 1909 but was rebuilt within the original walls for Capt. Edward Carter. It was a fashionable boardinghouse after the Civil War and is now law offices.

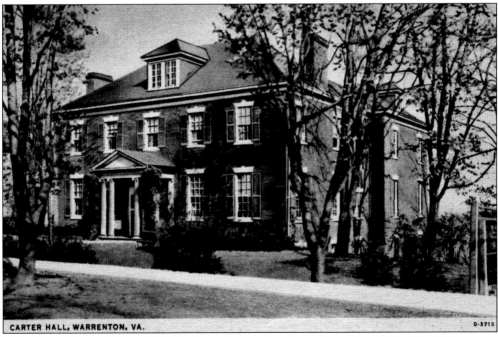

CARTER HALL, WARRENTON, VA.

This shows Carter Hall, at 31 Winchester Street, in early spring or late fall with the leaves not on the trees. Across the street today from Carter Hall is a parking lot for the Fauquier Bank. A little further down, just off Winchester Street at 12 Smith Street, is a house that was built in 1831 for James Caldwell, founder of the first county newspaper, *Palladium Liberty* (1817).

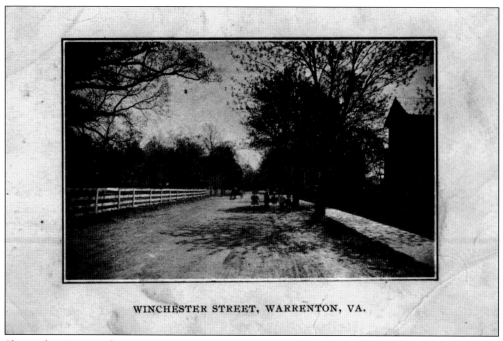

WINCHESTER STREET, WARRENTON, VA.

Shown here is Winchester Street in Old Town Warrenton. Winchester Street is home to many historic homes, such as Carter Hall, Britton Hall, Paradise, and Conway Grove. Conway Grove at 101 Winchester Street was built in 1820 for Dr. James Westwood Wallace, a physician to Thomas Jefferson and James Madison.

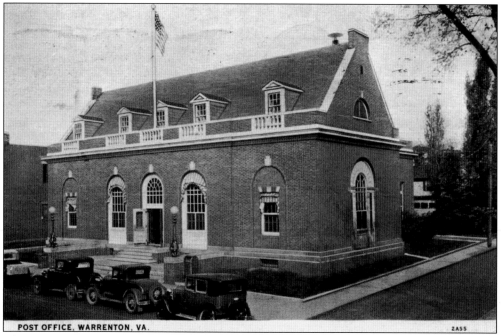

POST OFFICE, WARRENTON, VA.

This photograph of the post office in Warrenton shows some of the county's first automobiles. Notice behind the post office is the impression of a neighborhood with houses. Today behind the post office is one of Old Town's municipal lots for residents and visitors to park in.

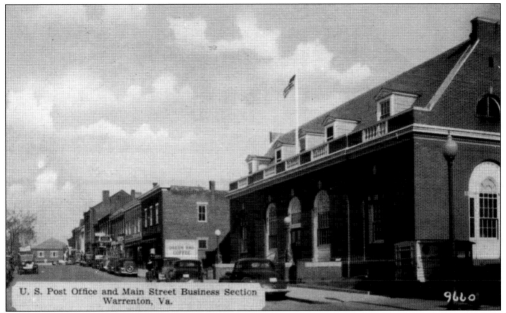

U. S. Post Office and Main Street Business Section
Warrenton, Va.

9660

Looking west down the Main Street business section, here is the U.S. Post Office. One can see one of many artists' billboards advertising "Green Bag Coffee." This building at 45 Main Street has seen a lot of changing businesses over the years. Until the building of Mathew and Fewell's Clothing Store in 1926, it was a vacant lot. In 1920, H. B. Carter bought the building, and in 1934, Carter's Furniture opened.

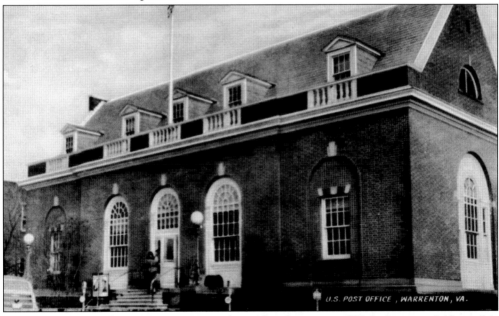

U.S. POST OFFICE, WARRENTON, VA.

The original post office in Warrenton was located at the corner of Main Street and Alexandria Pike, currently where Designs by Theresa sits. It moved to its present-day location at 53 Main Street in 1919. Before the post office was built on this property, it was a vacant lot hosting many entertainments and revival meetings. Before 1899, the City Drug Store, C. F. Galloway Livery and Sale Stable, and Marble Works were in this spot on Main Street.

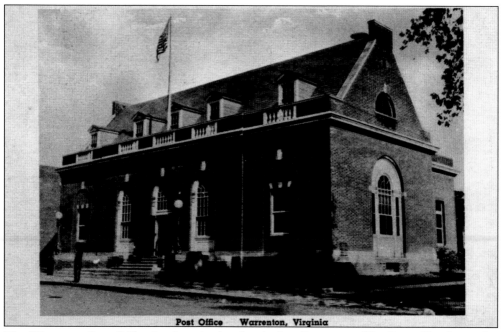

Post Office Warrenton, Virginia

The Warrenton Post Office has been updated to be handicap accessible. Post office boxes dot the inside rooms. Visitors can go around back and see the many trucks coming in and out of the loading and unloading area. In 1999 and 2000, President Clinton gave the Warrenton Post Office the President's Award for its support of volunteerism in the national capital area.

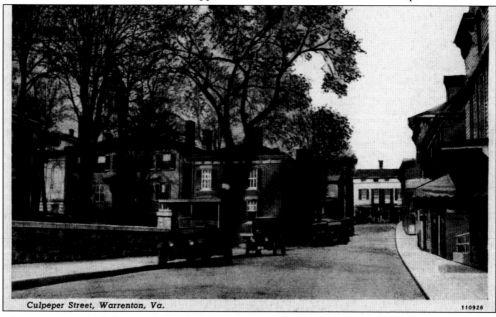

Culpeper Street, Warrenton, Va. 110926

This is a picture of Culpeper Street, looking north toward Main Street in Old Town. On the left, practically out of view, is the Warren Green. To the right is where the Fauquier Club and *Fauquier Times Democrat* are located today. This picture also shows the California Building, which was built with profits from the gold rush by William "Extra Billy" Smith. Before housing the Fauquier Club, this building was known as the Beckman house, built in 1854 for Judge J. G. Beckman.

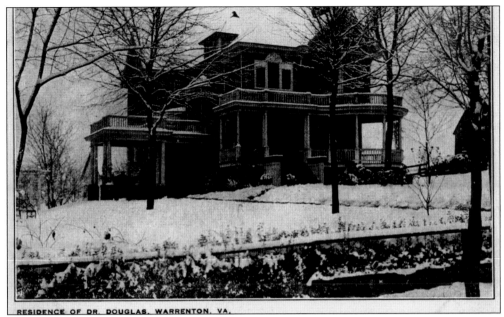

RESIDENCE OF DR. DOUGLAS, WARRENTON, VA.

The residence of Dr. Douglas is at 158 Culpeper Street, in between Mecca and the Marr House. Across the street is the Keith House, as well as what was once the Ullman Home. The Ullmans owned a department store on the corner of Lee Street and South Third Street. James Keith was president of the Court of Appeals of Virginia. Joseph Ullman served as the president of the family business until he died in 1953.

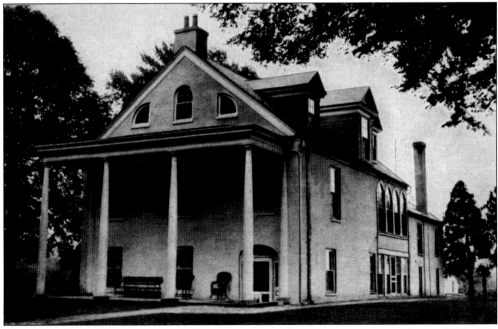

William "Extra Billy" Smith built Monte Rosa, now known as Neptune Lodge, in 1845. The large brick stables behind the house were used as a relay stop for the mail and stage line from Washington, D.C., to Milledgeville, Georgia. William "Extra Billy" Smith was born in King George County at Merengo, his father's old homestead.

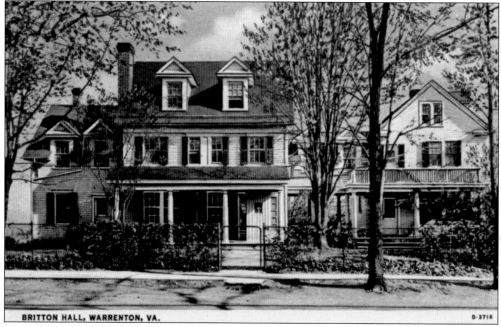

BRITTON HALL, WARRENTON, VA. D-3716

Britton Hall, built in 1790, was the birthplace of Dr. William Edmonds Horner (1793–1853). Dr. Horner was the author of the first American text on pathology, which was published in 1835. The west wing of Briton Hall was added on to the original east wing in 1909. Britton Hall was occupied by Horner descendants for 150 years.

RESIDENCE OF C. F. GAINES, WARRENTON, VA.

Pictured here is the house known as Paradise. Built in 1758, it is the oldest home in Warrenton and was built for Col. Martin Pickett, a solider in the French and Indian War, delegate to Virginia Constitutional Convention in 1788, and largest landowner in the area. It sits off of one of the many round corners along Winchester Street.

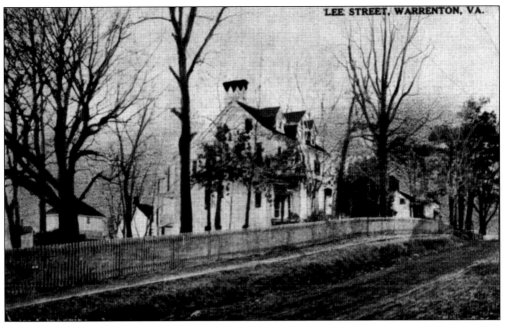

Located on Lee Street, just one block south of Main Street, this house was built in 1834 for Robert Brent. From 1866 to 1901, it was the home of Gen. William H. F. Payne, chief of the Confederate Black Horse Cavalry. Next door is the Mary Shepherd House, built in 1850.

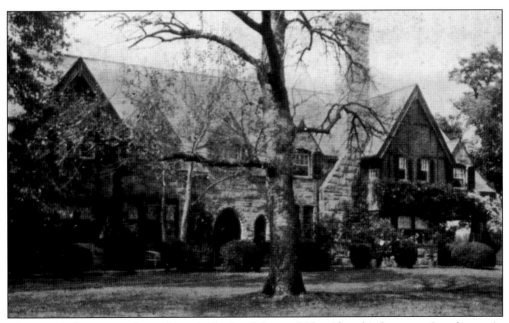

Not exactly known to the author, the back of the card identifies this home as Creedmoor in Warrenton. It shows many of the similar architectural details that can be seen today in the old houses around Fauquier County.

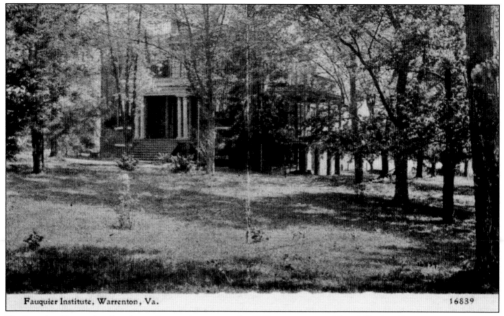

Fauquier Institute, Warrenton, Va. 16839

Today the Fauquier Institute is an apartment building managed by Alls Real Estate, a property rental provider offering housing mainly in Warrenton and Northern Virginia. Outstanding suites are available for rent inside the 12-unit "East Lee Street Mansion." Located just a few blocks from Old Town, suites are completely furnished to include the following: bedroom, living room, dining room, and bed/bath linens.

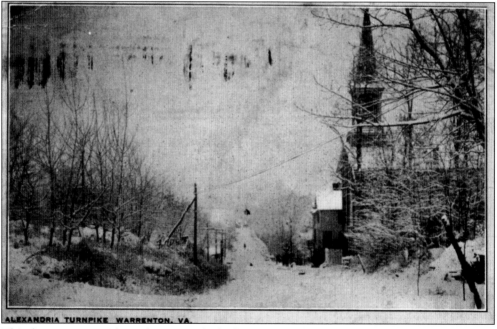

ALEXANDRIA TURNPIKE WARRENTON, VA.

This shows a snowy Alexandria Turnpike looking northeast toward the cities of Alexandria and Washington, D.C. On the left is a forest where the current Warrenton Library is located, while on the right is the Baptist church. This photograph was most likely taken near the foot of the Fauquier County Courthouse.

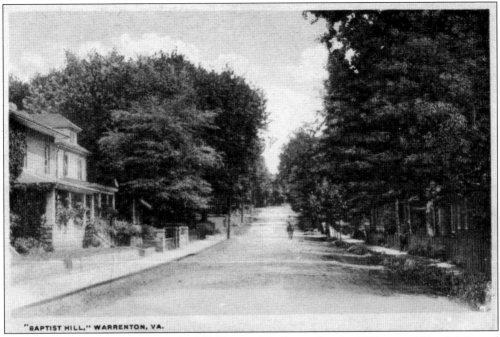

"BAPTIST HILL," WARRENTON, VA.

Looking east along Main Street in Old Town, this shows Baptist Hill toward East Main and Falmouth Streets. Brentmoor is located a little ways down the street on the left. The back of the card is postmarked 1924. The sender had been over in the Shenandoah Valley the day before visiting the Luray Caverns. At the spot where this was taken is the Warrenton Baptist Church.

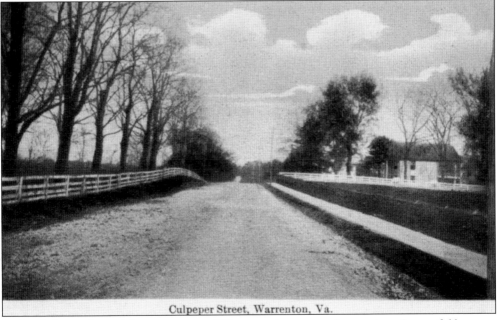

Culpeper Street, Warrenton, Va.

Today Culpeper Street is home to some of Warrenton's most stately mansions. Successful lawyers, merchants, and public figures built these well-preserved homes in the 1800s. Among these homes is Mecca at 194 Culpeper Street. Mecca is known to have some of the finest rooms in town. Mecca was also used as a hospital after the First and Second Battles of Manassas.

33

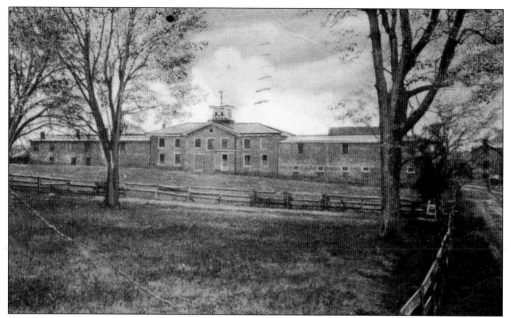

The Old Stage Coach Depot was on the Charlottesville-Warrenton Turnpike and behind Neptune Lodge on Culpeper Street in Old Town Warrenton. Today the only depot that people refer to while in Warrenton is the old train depot that is on South Third Street. A trunk line as part of the Orange and Alexandria Railroad reached Warrenton in 1852. Culpeper gained rail access on the Orange and Alexandria in 1852.

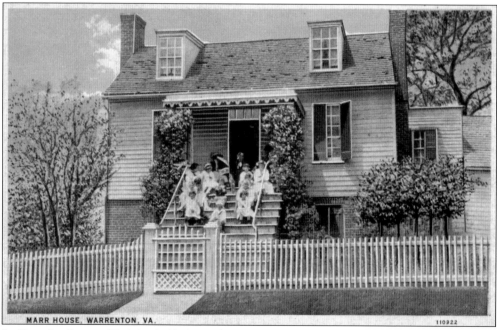

MARR HOUSE, WARRENTON, VA. 110922

In *Fauquier County, Virginia, 1759–1959*, the Marr House is said to still have the original pine mantels. The book also states some of the original Marr possessions are still located in the house, such as a letter from Captain Marr. The old brick walkways are bordered by flowers and lead to an attractive rear yard and garden. The Marr House is located at 118 Culpeper Street.

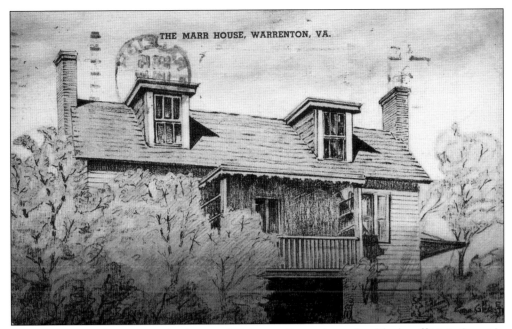

The Marr House is a very quaint house of Culpeper Street, just a few blocks off Main Street in Old Town. It remains much as it was 100 years ago. Across the street is the Keith House, built in 1816 by Thomas L. Moore. Moore and Marr married sisters, the daughters of Dr. Gustavus Horner. The Keith House is located at 127 Culpeper Street.

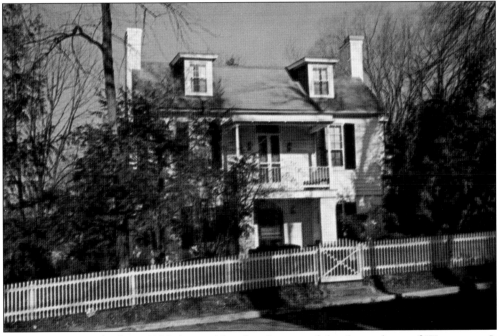

The Marr House, built in 1830, is considered to be one of the show places of Warrenton. It was once the residence of the Marr family and home of Capt. John Quincy Marr, the first Confederate casualty of the Civil War. Marr was killed at Fairfax Courthouse on June 1, 1861. Today a monument has been erected there in his memory.

This home was originally part of the Fauquier Female Institute, located at 194 East Lee Street with beautiful Italianate style architecture. The institute opened in 1857 as a boarding school for girls and was open until 1925. One of its boarders was Gen. Douglas MacArthur. He was a young boy in the late 1880s when he visited his aunt here. In 1985, it was purchased by the Sunrise Assisted Living Retirement Communities and was renovated into an assisted-living residence.

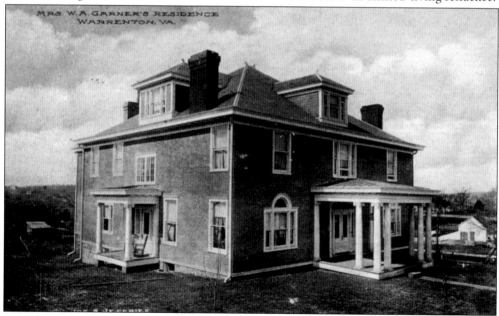

In 1925, the first Fauquier Hospital opened in the old Garner House. This was made possible because of 16 citizens who formed a hospital association and underwrote the purchase of the property for $14,000. The hospital could handle up to 25 patients in emergency situations but usually kept a limit of 20. The hospital stayed open until 1940, when the equipment was sold. It reopened in 1942 as Physicians Hospital, Inc.

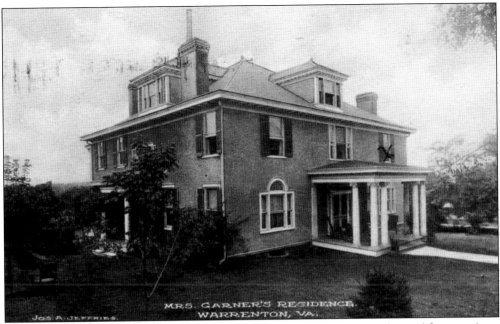

Mrs. Garner's residence in Warrenton is located on Waterloo Pike. It has changed from a private residence to being a hospital to being updated for individual office space. While the hospital was operational, next door was an Esso gas station and automobile repair shop. Today this Esso station has been converted into a fantastic bakery, offering homemade breads, pies, sandwiches, and other tasty treats.

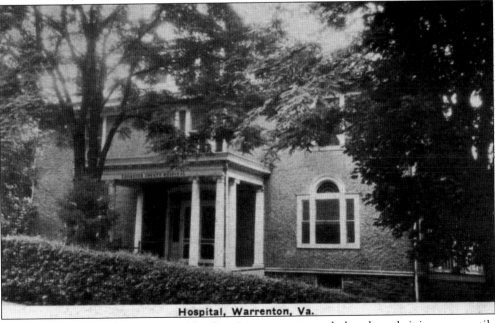

Hospital, Warrenton, Va.

By 1853, Warrenton had a railroad leading into town, several churches, thriving mercantile establishments, a weekly newspaper, and two schools. During the Civil War, Warrenton was near the scenes of great battles and bloody skirmishes. During these battles, its churches and schools served as hospitals for the wounded.

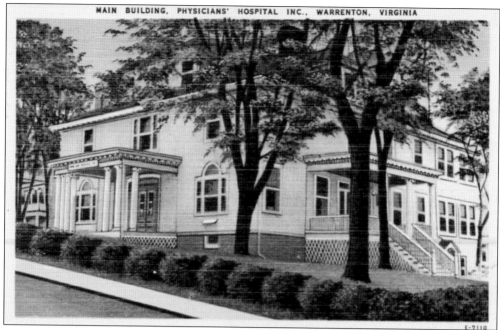

The Physicians Hospital was known as a modern, well-equipped institution owned by doctors of Fauquier and adjourning counties. The beginning of the Fauquier County Hospital System goes back to 1954 with a second effort to raise money for a new hospital that was led by local citizens, businesses, and banks. This paved the way for the state-of-the-art hospital on the bypass today.

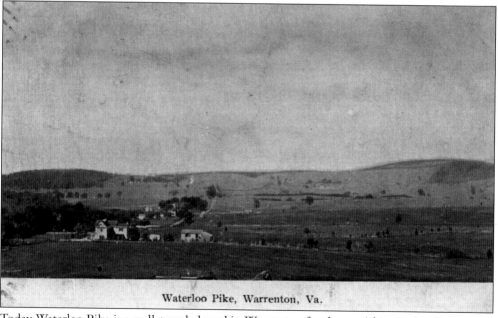

Waterloo Pike, Warrenton, Va.

Today Waterloo Pike is a well-traveled road in Warrenton for those wishing to head out to the bypass or further west toward the Blue Ridge Mountains. In the historic district is 74 Waterloo Street, a home built in 1812 for Thaddeus Norris, operator of the Norris Tavern. Today this stately white and green mansion is home to Chip Shot Clothing and Gifts.

Owned by Mrs. J. G. Shipe, this tourist home was located at 811 Waterloo Street, which was just one block from Routes 211, 15, and 29. It maintained five baths, both private and connecting. Today the numbering of houses and buildings seems to have changed, so this makes it tough to find an exact placement of the Shipe residence.

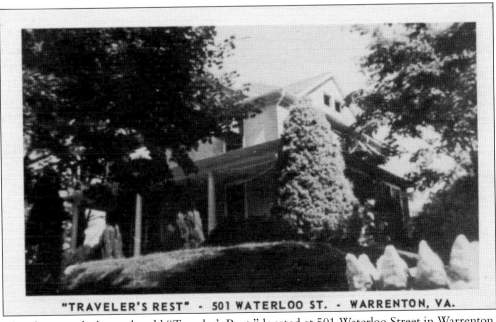

"TRAVELER'S REST" - 501 WATERLOO ST. - WARRENTON, VA.

The photograph shows the old "Traveler's Rest," located at 501 Waterloo Street in Warrenton. This was before the advent of the motel and hotel, when most stayed in what would be considered a bed-and-breakfast today. Visitors to Old Town can still travel on Waterloo Street and take in the houses that look similar to the one shown in the card.

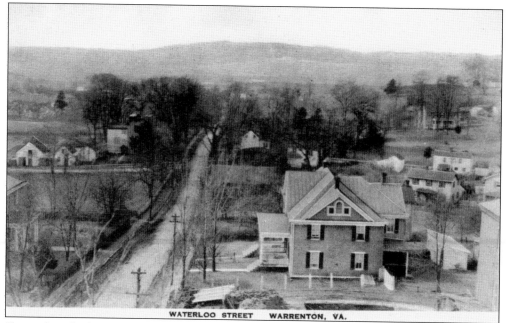

WATERLOO STREET WARRENTON, VA.

Shown here looking west heading out of town toward the Blue Ridge Mountains is Waterloo Street in Warrenton. This is where visitors can meet up with the bypass. Warrenton sits atop a hill, making views like this fairly common around town. Today the land shown here is filled in with homes along streets such as Chestnut, Frasier, and Fairfax.

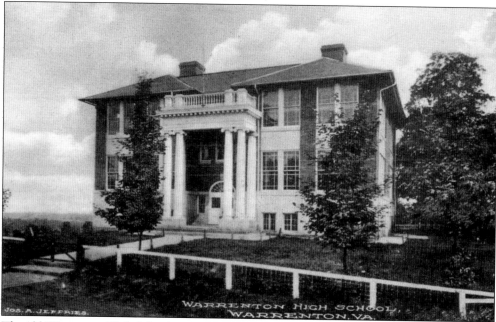

The old Warrenton High School was located on Academy Hill and was open until 1924, when a larger facility was built not far down the hill. At this time, this became the elementary school. The location of the school offered sweeping panoramas and vistas of the adjacent farmland. Today Academy Hill has largely been developed for residential houses, with Walker Drive cutting through.

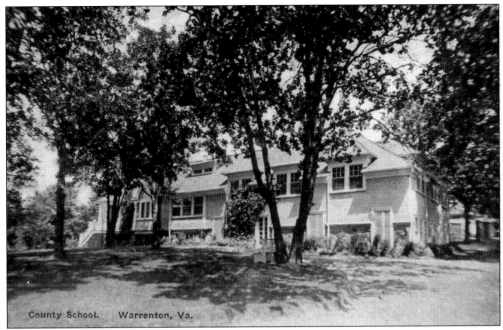

County School. Warrenton, Va.

The Warrenton Country School is not far from some of the most beautiful farmland surrounding Warrenton on Springs Road. Springs Road leads to Route 229 and can be a passageway for folks looking to use an alternative route when going to Culpeper. While traveling Springs Road today, great estates such as Waverly Farm and St. Leonard's line the road with picturesque scenes.

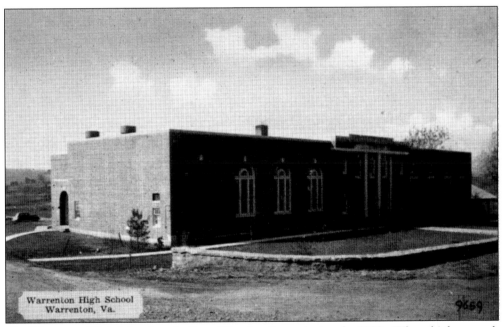

Warrenton High School
Warrenton, Va.

The Warrenton High School was built on Waterloo Street during the 1930s. When this happened, the high school on Academy Hill was transferred to being another elementary school. Today the majority of the kids in the town of Warrenton attend Fauquier County High School on Waterloo Road, behind the Huntsman Town Village Shopping Center.

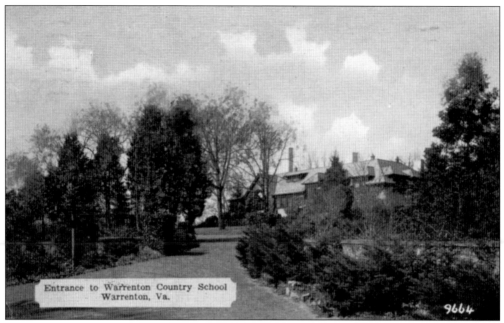

Entrance to Warrenton Country School
Warrenton, Va.

9664

This is the entrance to the Warrenton Country School, which is at the corner of Springs Road and Shipmadilly Lane. It was established by Lea Bouligny in 1912 and operated until 1950, when the property was sold to the U.S. government. Today it is known as the Warrenton Training Center. The Dakota House and the Stables at EMO are not far from the Warrenton Training Center.

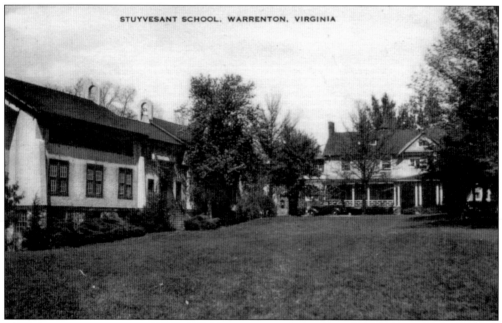

STUYVESANT SCHOOL, WARRENTON, VIRGINIA

The Stuyvesant School, located on Winchester Street, was a non-military boarding school that opened its doors in 1912. It closed its doors in 1954. The site is now home to St. John the Evangelist Catholic Church and School. It sits at the corner of Winchester Street and King Street.

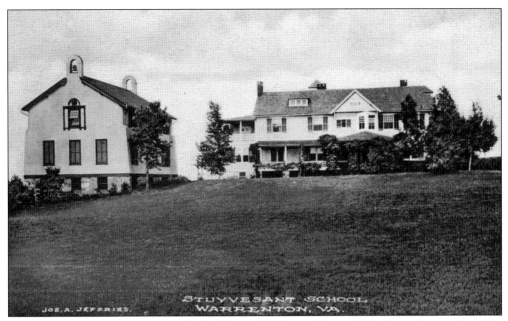

The main classroom structure on the left burned during a fire in 1946. It was later replaced by a concrete-block structure in the same place. Today this structure is still standing and is home to the parish offices. The building on the right served as a dining hall and residence hall for both the faculty and staff.

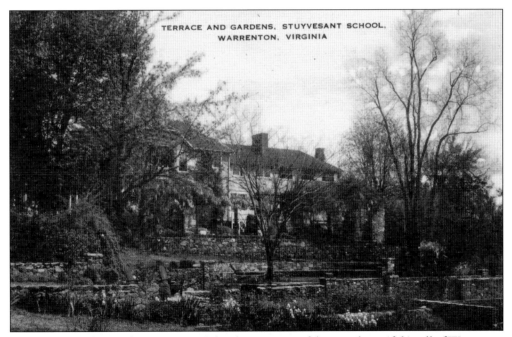

The terrace gardens at the Stuyvesant School were some of the most beautiful in all of Warrenton during their heyday. Some of these gardens can still be toured today. When on the tour, one can see the dedication plaques scattered throughout. Many statues and shrines also reside in the gardens. Behind the church and gardens is St. John's School.

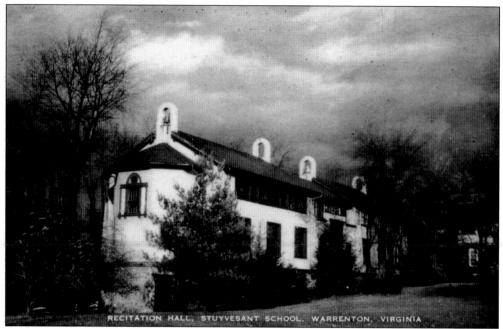

The Recitation Hall at the Stuyvesant School in Warrenton is shown after it had been added on to, with space being more than doubled since its original construction. Another building is on this property today that acts as a hall for gatherings. Out front is a Knights of Columbus sign. Housing developments such as North Rock now surround the property.

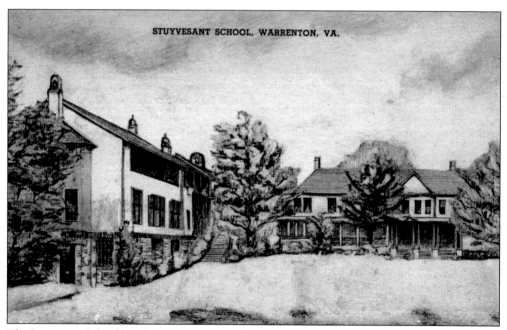

The Stuyvesant School in Warrenton was one of many Warrenton schools. Today St. John's Catholic Church resides on the property. Out front is a beautiful fountain built by the Knights of Columbus Council 5561. It is a monument to "the sanctity of life" and was dedicated in July 2000.

This photograph shows a view of Professor Shea and the bell at the Stuyvesant School. Although the Stuyvesant School is no loner standing, visitors today can still come to where it was located and find the bell. It sits just behind the church. The church recently went through construction to enlarge the facility.

In 1890, a group of investors from around Virginia, including several Warrenton businessmen and attorneys, put together a plan to create a resort community, South Warrenton, on 220 acres of fields and woods along the southern boarder of Warrenton. The ambitious outfit called itself the East Virginia Mineral and Warrenton Improvement Company. Its plan and the centerpiece creation of the Blue Ridge Hotel never developed.

45

This recent picture of the post office shows Main Street as one would see it today. Usually, a steady stream of residents and visitors can be seen coming in and out all day long. Around the holiday season, one can expect long lines for shipping packages to family and friends.

Shown here is Culpeper Street, picturing *Fauquier Times Democrat* and Allen Real Estate. Across the street is the new county court and Warren Green Building. This part of Culpeper Street is home to a variety of professional offices, including attorneys, accounts, and salesmen. Visitors can also see the *Fauquier Democrat*'s original hot-lead Linotype, which was used from 1936 to 1975.

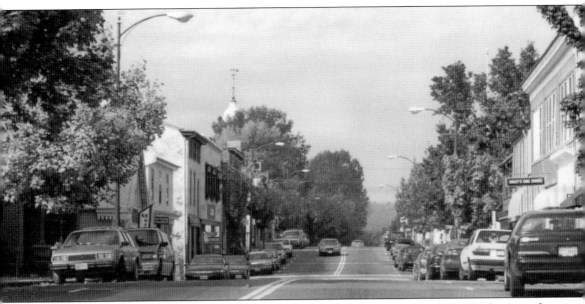

Here is Main Street looking west toward the Blue Ridge Mountains. Only the busiest of individuals could pass through Old Town on Main Street and not take notice to the lovely shops and historic charm. Old Town Warrenton, also known as the Warrenton Historic District, was listed on the National Register of Historic Places in October 1983.

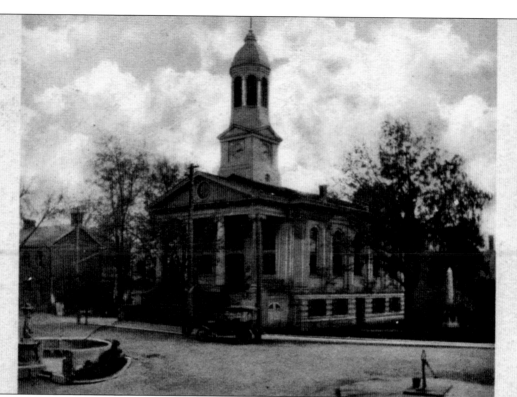

After the fire destroyed the earlier buildings of 1790, 1819, and 1854, this courthouse was built in 1890. Richard Henry Lee picked the site because it was the highest point in town. The current courthouse is said to be a reproduction of the 1854 building, which was patterned after the Parthenon in Athens. It displays true grandeur on a small-town scale.

Three

THE WARREN GREEN

AND

COURTHOUSE SQUARE

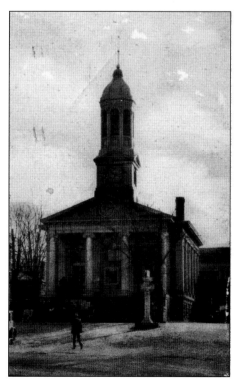

Pictured here is the Fauquier County
Courthouse at the intersection of Main Street,
Alexandria Pike, and Winchester Street,
anchoring Old Town Warrenton for all residents
and visitors. This card shows one of Warrenton's
businessmen crossing the road, hoping perhaps
to get to his automobile or an appointment
in the courthouse. Also seen is the sign that
stood in the middle of the road directing
traffic to one of many of the surrounding
towns and counties adjacent to Fauquier.

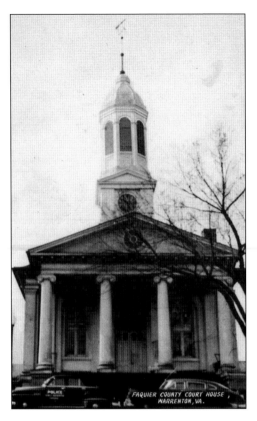

FAQUIER COUNTY COURT HOUSE,
WARRENTON, VA.

Pictured here is the Fauquier County Courthouse with two automobiles, including a police car. Today parking in front of the courthouse is strictly prohibited, with most police cars parking nearby along Court Street. To many, Old Town Warrenton represents the ideal hometown that people dream about living in. It can often help residents of Northern Virginia escape from the congestion and stress of everyday life.

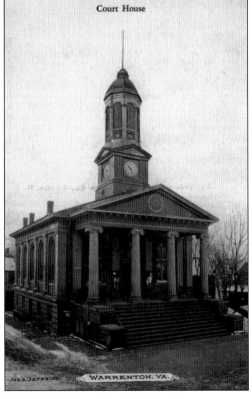

Court House

JOE A. JEFFRIES WARRENTON, VA.

Shown here is a classic view of the courthouse by Joseph A. Jeffries, most likely taken from close proximity to the Jeffries Building on the north side of Main Street. The Jeffries family lived at 15 Main Street in a building that was constructed in 1847. Unfortunately, it burned in an 1873 fire. They operated the drugstore until March 1948, when they sold it to Robert H. Gardiner Jr. The Jeffries family, as well as many others, lived in the apartments on the second and third floors above the store.

50

Pictured head-on is the courthouse, showing the Fauquier County National Bank to the rear. In the photograph, the clock tower houses a weather vein that is still visible today. The courthouse bells still chime on the hour, letting the people of Warrenton know what time it is. Only one of its original chimneys can be seen. Today this chimney is still present.

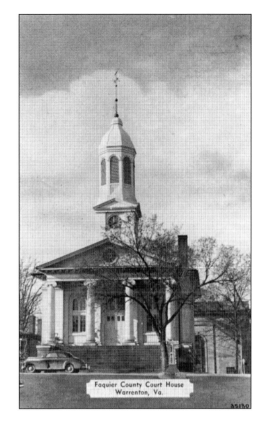

Fauquier County Court House
Warrenton, Va.

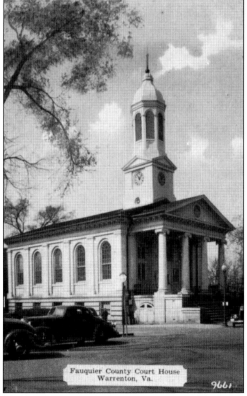

Fauquier County Court House
Warrenton, Va.

Seen here is another view of the Fauquier County Courthouse from Main Street. The automobile pictured gives a clear date in time when this was photographed. Today automobiles are sometimes kept off Main for special events and festivals. Every year, there is a Father's Day classic car show, featuring some of the nicest vintage cars that can be found in Fauquier and surrounding counties.

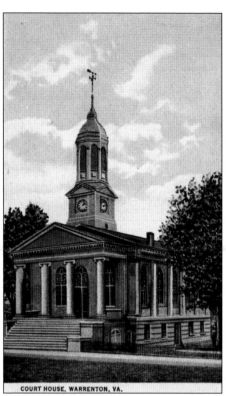

COURT HOUSE, WARRENTON, VA.

Here is an artist's rendering of the courthouse in Old Town, which shows a fence enclosing the courtyard to the right of the building and in front of the old jail. Today this fence no longer exists, and the courtyard is decorated with special artifacts. One of these artifacts is the slave auction block that was once located on the northeast corner of Main Street and Alexandria Pike.

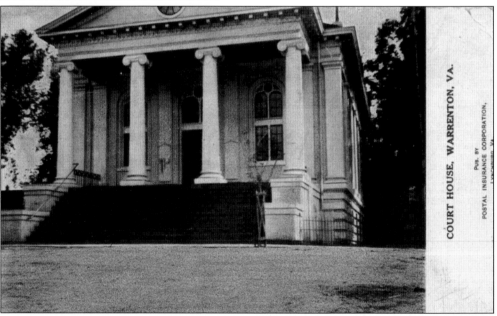

COURT HOUSE, WARRENTON, VA.

Pub. by
POSTAL INSURANCE CORPORATION,
LYNCHBURG, VA.

This postcard shows the entrance of the courthouse on Main Street. Every year, a giant Christmas tree is put up for Gum Drop Square activities. Sometimes during special events, choirs and orchestras are positioned on the courthouse steps for all to listen. Every year, "An Evening Under the Stars" is coordinated near this location on Main Street with the purpose of generating monies to support the Partnership for Old Town Warrenton.

52

After the first courthouse burned, the Fauquier County Courthouse was built in 1853. The 1853 courthouse was later restored after a second fire in 1889. It contained portraits of Chief Justice John Marshall and Lord Francis Fauquier, for whom the county was named. An almost identical picture is be seen today by visitors and residents.

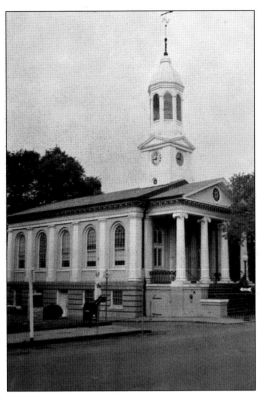

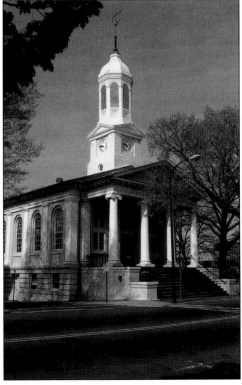

The courthouse known as Fauquier County's premier Classical Revival landmark has been a mainstay for over 150 years. The architecture found in Old Town is a stark contrast to those buildings found on the Warrenton bypass. During the 1950s, the bypass brought the first fast food chain to Warrenton, the Tastee-Freez.

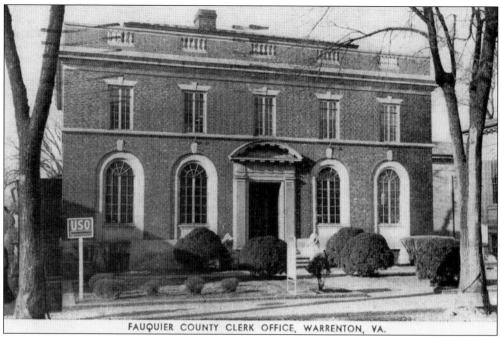

FAUQUIER COUNTY CLERK OFFICE, WARRENTON, VA.

In front of the Fauquier County Clerk's Office now sits a statue of Fauquier native John Marshall that was commissioned by Fauquier County's bicentennial committee. It was dedicated in 1959. At the 250th-year celebration of Fauquier County on May 1, 2009, a time capsule was placed out front to be opened in 50 years.

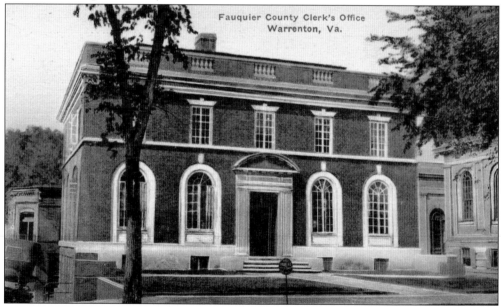

Fauquier County Clerk's Office
Warrenton, Va.

The Fauquier County Clerk's Office on Main Street, adjacent to the courthouse, was built in the 1920s and replaced an earlier building in the same place that was directly on Main Street. The county clerk's office is bordered by Culpeper Street as well as Court Street. Behind the clerk's office is a building near the intersection of Culpeper Street that was once the Gaines and Brothers Bank.

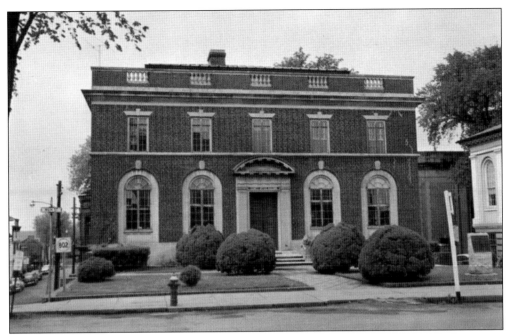

In front of the Fauquier County Clerk's Office is a memorial to Fauquier County's residents who made the full sacrifice during World War II in the U.S. military. A small walkway, with no automobile traffic, is directly behind the building and is known as Wall Street. It is home to professional offices.

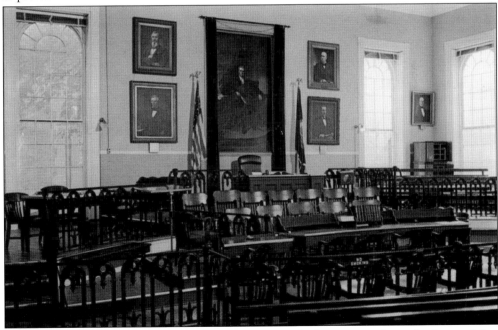

Alexandria Pike, just outside the Fauquier County Courthouse, was the main thoroughfare leading residents to Warrenton from the north. However, it was a dirt road until the mid-19th century. Once inside the courthouse, visitors will see the famous painting of John Marshall. Many county officials' offices are also housed inside.

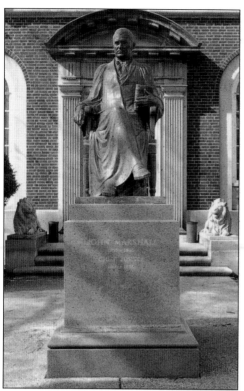

The statute of Chief Justice John Marshall stands in front of the County Office Building at 4 Main Street. Pre. John Adams appointed this Fauquier County native as chief justice of the Supreme Court in 1801. John Marshall supported the Revolution, fought for the adoption of the Constitution, and was chief justice for 34 years. He is said to be someone who largely defined the character of the nation's federal structure.

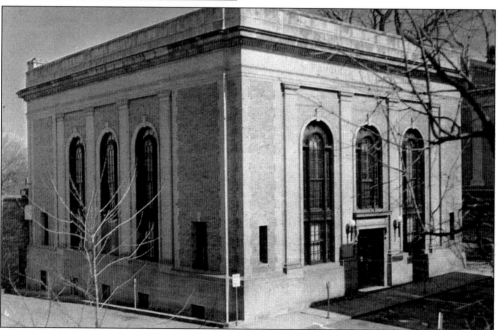

Once home of the Fauquier National Bank, Fauquier's oldest bank established in 1902, this is now home of the Town of Warrenton officials' offices. The Fauquier National Bank occupied this building between 1925 and 1972. The old bank alarm still sits on the southwest corner of the roof and can be viewed by those individuals paying careful attention from the street.

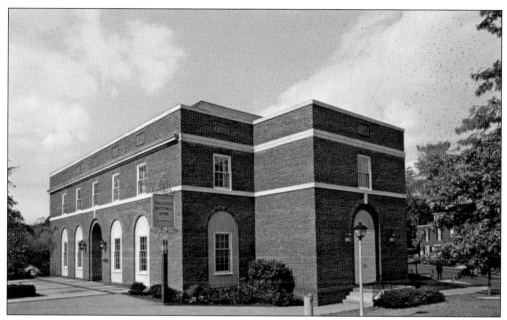

The Fauquier National Bank moved to its new home at 10 Courthouse Square in Old Town in 1972 and now has branch locations in both Fauquier and Prince William Counties. It is located in seven towns and has 10 total branches. In its Old Town Warrenton location, scenes of Warrenton can be seen hung around the branch lobby. It also sells a large commemorative map of Fauquier with information and pictures of special places.

The old jail is situated in close proximity to the rear of the courthouse and is an oblong two-story building, surrounded by a yard to the rear that is enclosed in high stone walls. It is said to be one of many haunted landmarks in Old Town. Today it is one of the most perfectly preserved old jails in the commonwealth. It features a maximum-security cell block, the John Marshall Room, a Rappahannock canal boat, a colonial kitchen, a wine cellar exhibit, and much more.

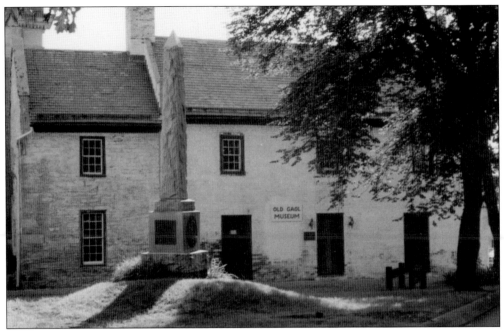

The Old Gaol Museum, a part of Courthouse Square, was built between 1808 and 1823 and served as the Fauquier County Jail until 1964. It is listed as a national landmark and has been maintained since 1965 by the Fauquier Historical Foundation. In the summer of 2006, the jail was taken back to its original brickwork with the removal of the white paint.

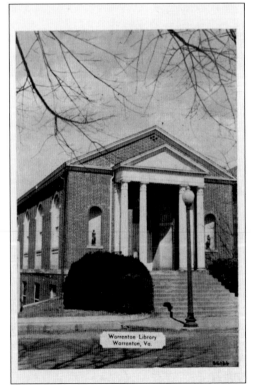

The Warrenton Library is pictured here showing its past location in the John Barton Payne Building, located at No. 3 or No. 2 as part of Courthouse Square. Before becoming the John Barton Payne Building because of his gift to make the building possible, it was referred to as the Library Annex. Today the building hosts a variety of community events, including Santa Claus at Gumdrop Square in the month leading up to Christmas.

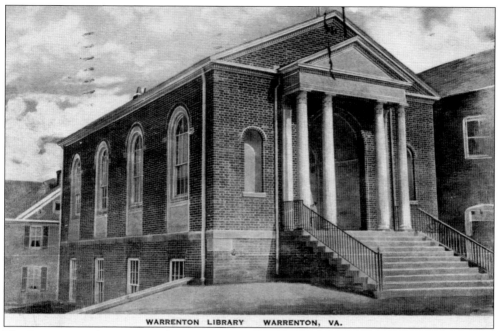

WARRENTON LIBRARY WARRENTON, VA.

The Warrenton Library moved from the John Barton Payne Building to the corner of Winchester Street and Alexandria Pike in April 1982. This new space was built in 1929 and was originally known as Garrett's Garage. It was used for over 50 years as an automobile dealership and moving and storage facility before being donated to the town by philanthropist Edward L. Stephenson. The garden in front of today's Warrenton Library was dedicated in 1999.

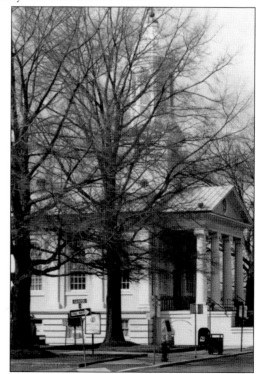

Shown here through the leafless trees during the winter, the Fauquier County Courthouse has an unmistakable paint job, which includes soft yellows, whites, and grays. Both the trash can and post office drop box have changed positions, but everything else remains almost the same. Culpeper Street even remains a one-way street escorting vehicles to Main Street.

In front of the Old Jail Museum sits a monument to John S. Mosby dedicated in 1920. Part of this area is a beautiful courtyard with many historic artifacts and important information for residents and visitors to read and take in. Included in the things on display are a memorial to the Persian Gulf War veterans, Lafayette's stepping stone, and the concrete bench once in front the courthouse. Hangings are said to have taken place in the yard until 1896.

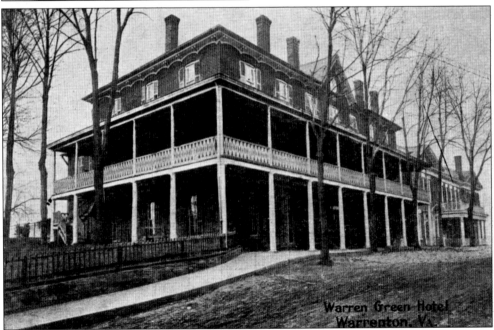

Located one block south on Hotel Street in Old Town Warrenton, the Warren Green Hotel was known to its guests as the "Little Waldorf." However, some thought that rather than the Little Waldorf, it was more in the tradition of a true Virginia inn. In its heyday, the Warren Green gave the restrained elegance of aristocratic rural Virginia.

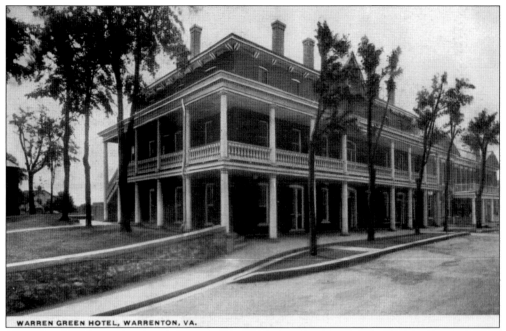

WARREN GREEN HOTEL, WARRENTON, VA.

The first inn recorded on the site of where the Warren Green Hotel was later constructed was Norris Tavern, built in 1819. Norris Tavern was host to such notables as General Lafayette (on his last visit to America) and Andrew Jackson. After it was Norris Tavern, it became a school known as the Warren Green Academy.

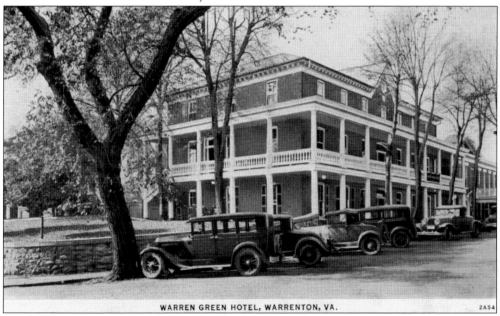

WARREN GREEN HOTEL, WARRENTON, VA. 2A54

In the early 1900s, automobiles increased travel and the demand for hotel services. Staying for almost an entire year, the Warren Green's most famous guest, Wallis Warfield Spencer, arrived between 1925 and 1926. But her stay was no vacation; it was to take up residency in Virginia to secure a divorce from Earl Winfield Spencer Jr. She went on to marry England's King Edward VIII. She later called her first year in Warrenton "the most tranquil I have known."

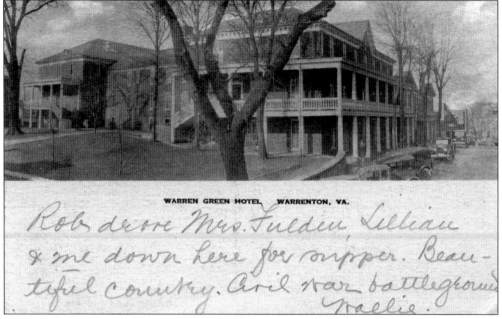

WARREN GREEN HOTEL, WARRENTON, VA.

Rob drove Mrs. Fulden, Lillian & me down here for supper. Beautiful country. Civil war battleground. Mallie.

In 1875, a new Warren Green Hotel was built that in years later became the property of Mrs. C. Ullman. It remained as property of the Ullman family until January 1957, when Mrs. Billie Richardson and Joseph W. Elliott purchased it. Two additions made after the beginning of the 20th century gave the hotel its 100 rooms. Some rooms were converted to apartments and some leased for commercial use. In the late 1950s, the hotel had 55 rentable rooms.

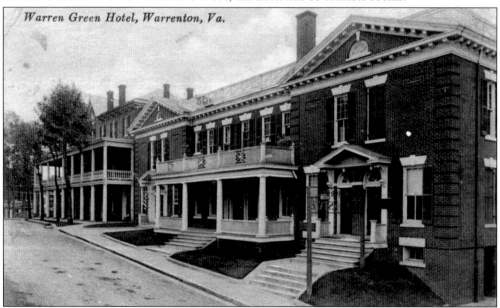

Warren Green Hotel, Warrenton, Va.

Enjoyment of the Warren Green was not limited to celebrities. For many years, townspeople and their guests used the hotel for all types of gatherings, receptions, and parties. People used to say that if townspeople wanted to meet someone in Warrenton, 9 times out of 10 they said "meet me at the hotel." People used the wide porches for sitting and talking, others often danced in the second-floor parlor, and families had supper together in the dining room.

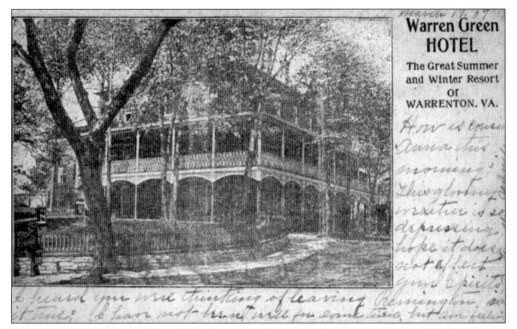

Built in 1819, the Warren Green Hotel was once known as the great summer and winter resort of Warrenton, Virginia. It has been said that if winter was exceptionally cold or snowy, some residents living out in the countryside would even close down their homes and take up residency at the Warren Green.

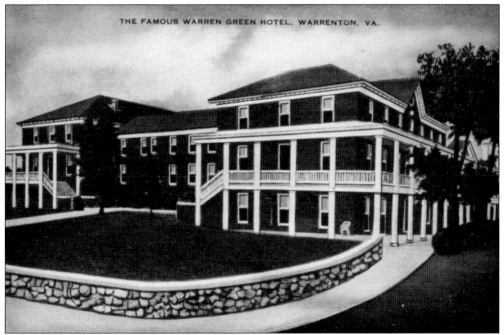

The lawn of the Warren Green, previously known as Norris Tavern, was the scene of a great banquette in honor of General Lafayette on August 23, 1825, on his visit to the United States in that year. Other famous visitors to the tavern included Henry Clay and Anne Royall, a pioneer newspaperwoman who stayed at the tavern in 1829–1930.

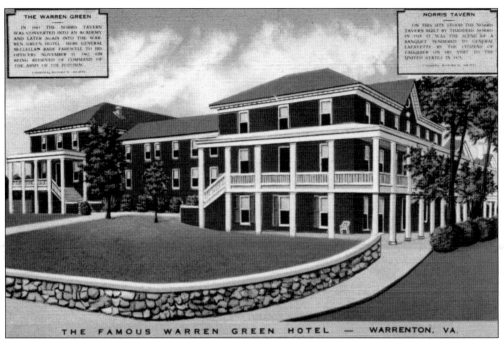

The famous Warren Green at the junction of U.S. 15 and U.S. 211 Business was known as a modern hostelry and a must-stop in the heart of Virginia's horse country. It was also known for its delicious food. Today, in the warm months, the Bluemont Summer Concert series takes place on the grounds in front of the Warren Green.

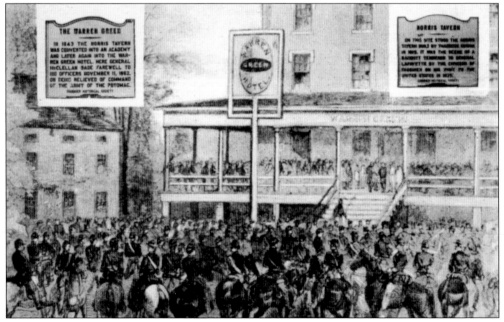

Relieved of his command, Gen. George B. McClellan said farewell to his officers on November 11, 1862, at the Warren Green Hotel, which is also where Gen. Ambrose Burnside, commanding the Army of the Potomac, had his headquarters prior to his advance on Fredericksburg. Civil War history is dotted throughout Old Town Warrenton.

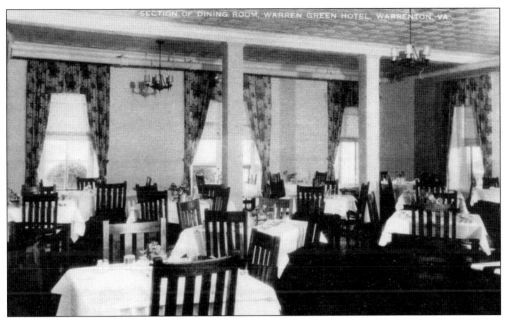

With the arrival of the Great Depression, business at the Warren Green dropped dramatically. After struggling with business for a number of years with different managers, the Ullmans contacted Barney Harris. Barney Harris started at the Warren Green in 1940 and instituted a number of changes. Part of this revitalization included changes made to the menu to offer better food. The Warren Green dining room was a popular place to eat for both guests and residents.

WARREN GREEN HOTEL GARDEN. WARRENTON, VA.

Today the Warren Green Hotel is known as the Warren Green Building. It is used for county employees including the Fauquier County Board of Supervisors, County Administration, and Commissioner of Revenue. On the first floor of the building, behind the lobby, the Fauquier County Historical Society has an exhibit on the history of the Warren Green, Fauquier County, and Old Town Warrenton.

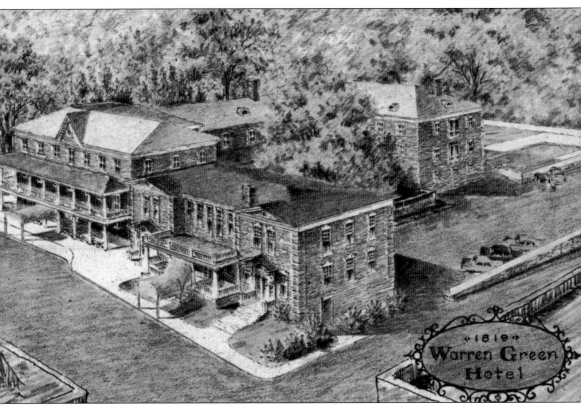

The Warrenton Green Hotel, located 45 miles from Washington, was known as being in the center of Mosby's Rangers' activities and in the heart of hunt country at the foothills of the Blue Ridge Mountains. It included 50 decorated rooms, Virginia cooking, swimming, golf, and many historic sites near by.

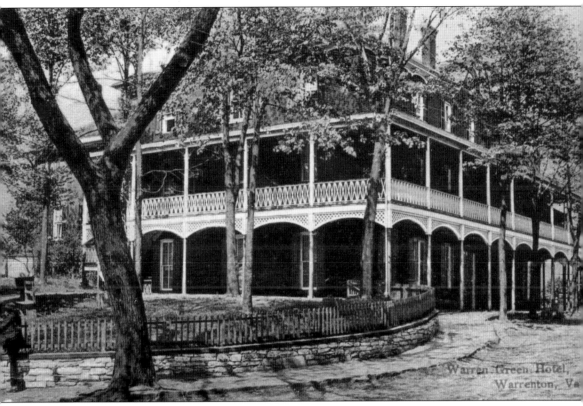

During his famous horseback ride on January 13, 1909, from Washington, D.C., to Warrenton, Pres. Teddy Roosevelt lunched at the Warren Green. President Roosevelt also addressed the people of the county and surrounding region from the balcony of the Warren Green. Residents of Warrenton were alerted of President Roosevelt's arrival by a telephone call from a New Baltimore storekeeper.

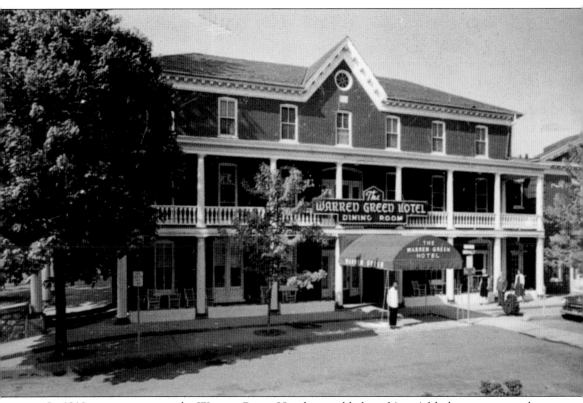

In 1910, a new annex to the Warren Green Hotel was added, and it quickly became a popular social spot for guests and county residents. In 1927, another wing was added for further space. By 1933, a major remodeling was needed to keep pace with changing and current lifestyles.

Four

SMALL TOWNS
AND VILLAGES

The countryside near Airlie Conference Center makes for the perfect walk in early spring. In 1956, Dr. Murdock and Jane Head purchased a large farm in the piedmont foothills near Warrenton. Thus began Dr. Head's plan to create a place where individuals and organizations could meet without distraction to discuss and exchange ideas in a natural setting. Airlie Conference Center was officially founded in 1960 as an "island of thought."

In 1963, Martin Luther King and other national civil rights leaders met at Airlie Conference Center to plan the March on Washington in August. Both black and white members of Fauquier County's business community also met at Airlie to discuss plans for desegregation of the county's restaurants and other public facilities.

Airlie Conference Center sits on a 1,200-acre farm at the foothills of the Blue Ridge Mountains a few miles north of Warrenton. The purpose of Airlie is to encourage the exchange of ideas and to provide a forum for the discussion of the problems within society.

The formal gardens at Airlie Conference Center have been a treat for conference visitors and those staying overnight for many decades. Weddings can be held outside for a spectacular setting. Not far from these formal gardens is the Local Food Project at Airlie, which was founded in 1998. This project demonstrates the significant role local food can play in an institutional setting. Garden staff work closely with chefs to integrate flavorful, nutritious, fresh-picked produce into delicious dining-room meals.

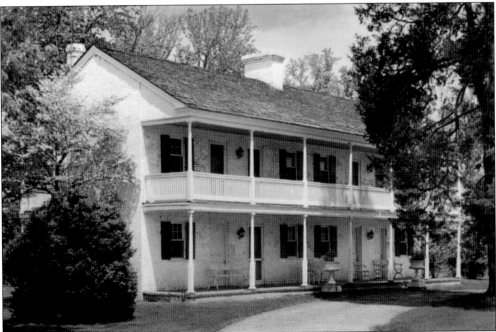

The Warrenton House at Fauquier White Sulphur Springs, 6 miles from Warrenton on Route 802 (Springs Road), is the one remaining cottage of the famous resort dating back to the late 1700s. Today the resort site is home to the Fauquier Springs Country Club. Large farms can be seen surrounding the club.

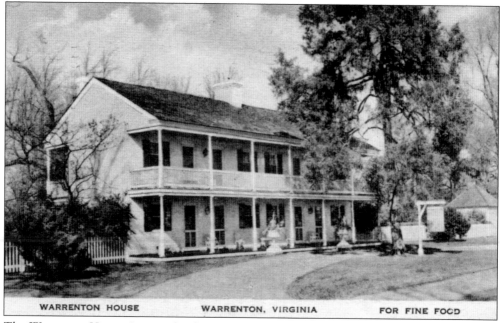

WARRENTON HOUSE WARRENTON, VIRGINIA FOR FINE FOOD

The Warrenton House, just south of Warrenton, was known for its fine food. If they are not careful, motorists can pass by this house today without even noticing it.

The Broad Run Baptist Church, organized by David Thomas on December 3, 1762, is the oldest Baptist church in Virginia in continuous existence since its organization. This photograph, taken in 1962, shows the church, which is very recognizable today. It is located near the intersection of U.S. Route 29 and Beverlys Mill Road in New Baltimore. Automobile passengers heading north on U.S. 29 to Northern Virginia probably pass it daily without knowing its historic significance.

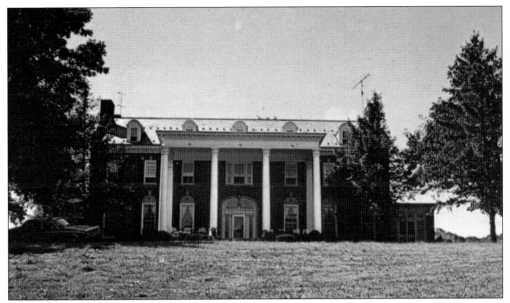

Pictured is a country estate that was once home to Cartwright's Vonderrosa Restaurant, located in the heart of the Virginia hunt country, Delaplane. On the back of this postcard, the building is described as a magnificent mansion that could seat 125 persons to a varied menu in four dining rooms. Lunch and dinner was served Wednesday through Saturday, while only dinner was served on Sunday.

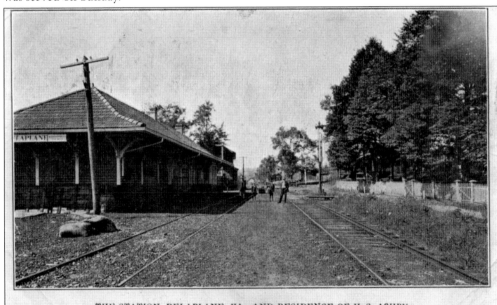

THE STATION, DELAPLANE, VA., AND RESIDENCE OF H. S. ASHBY.

Seen here is the railroad station in Delaplane and former residence of H. S. Ashby. This rail line going through Delaplane connects west to Markham and then further out in the Shenandoah Valley to Strasburg Junction. To the east, the line heads out toward Rectortown before going through The Plains and then on to Manassas. The Manassas Gap railroad was developed by farmers in the northern section of Fauquier County who were worried about being bypassed by the iron horse.

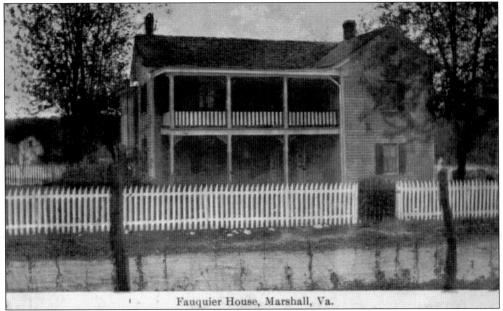

Fauquier House, Marshall, Va.

The Fauquier House in Marshall, Virginia, is one of many well-known homes and buildings in this quaint, sleepy village. Marshall, formerly known as Salem, sits along Route 55 and is directly adjacent to Interstate 66. Although Marshall has historically been an agricultural community, it has a designation as one of five service districts within Fauquier County. This designation has resulted in a renaissance of business and professional service offerings to the mostly equestrian and agricultural interests in the surrounding region.

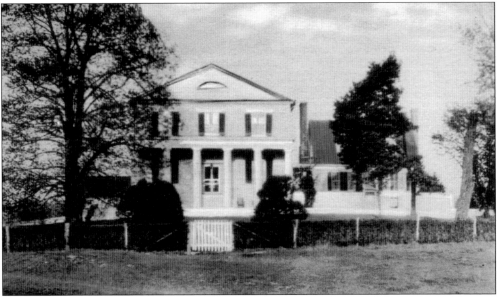

Oak Hill, once home to Chief Justice John Marshall, is located on John Marshall Highway in Delaplane, Virginia, near the village named after him, Marshall. The wood-frame dwelling, completed in 1773 when Marshall was 17, is a classic example of Virginia's Colonial vernacular. John Marshall became the owner of Oak Hill in 1785 when his father, Thomas Marshall, moved to Kentucky.

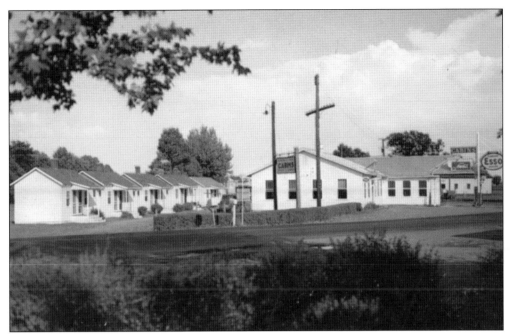

Located 7 miles south of Warrenton, Corner Tavern, once at the junction of U.S. 15-29 and U.S. 17 in Opal, was known as a modern cottage and restaurant. Its proprietor was J. M. Johnson. Opal has a crossroads location, ushering vehicles from many of the surrounding towns and counties. It is also known to many travelers heading south looking to connect from U.S. 29-15-17 to Interstate 95.

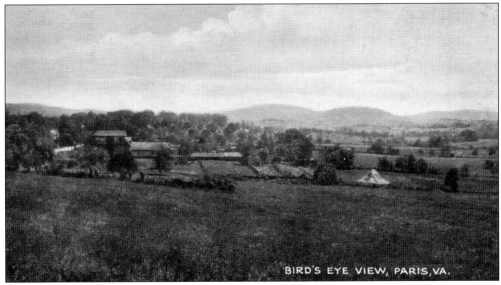

A bird's-eye view of Paris shows a strikingly similar scene to one observed today. For those who might be unfamiliar with Paris, it is a village located in the heart of Virginia's hunt country that was established in a strategic spot at the eastern base of Ashby Gap, along U.S. Route 17 and U.S. Route 50. Paris has a population of 51 with only one church, Trinity United Methodist Church on Federal Street. Many visitors to the area may travel right past Paris without even noticing it.

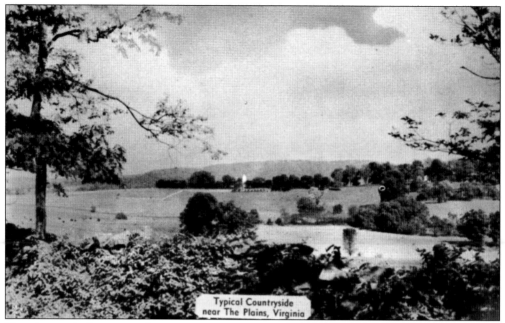

Typical Countryside
near The Plains, Virginia

Here is a typical countryside scene near The Plains, which is filled with mid-sized cattle and horse farms, rolling hills, and landscapes with crops when in season, and even a few wineries. Just north of The Plains is Halfway, located in between The Plains and Middleburg. Actor Robert Duvall once owned a restaurant in The Plains called the Rail Stop. He still makes his residence north of town at his 360-acre Brindley Farm.

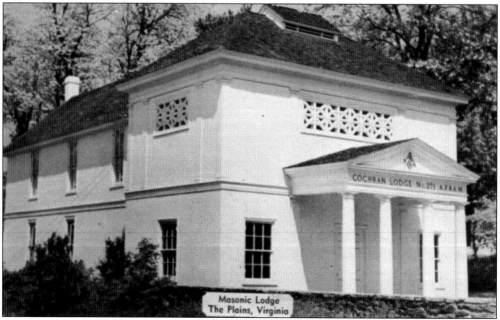

Masonic Lodge
The Plains, Virginia

Shown here is the Masonic lodge in The Plains. Today The Plains is a sharp contrast to the eastern suburbs of Prince William and Fairfax Counties. Although just 9 miles from Haymarket, a large bedroom community for the Washington metropolitan area, The Plains can seem like a world away. Small businesses anchor the historic charm of the village.

76

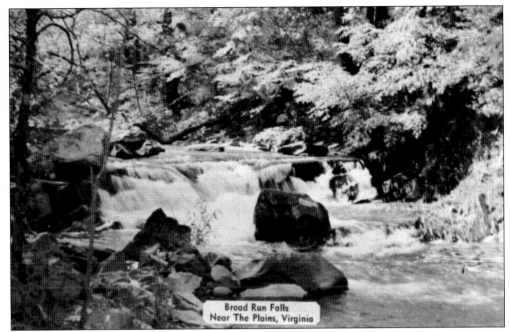

Broad Run Falls
Near The Plains, Virginia

This is a photograph of Broad Run Falls near The Plains. Broad Run is located on State Route 55 a few miles east of The Plains, just before entering Prince William County. Home to large agricultural operations specializing in crops and cattle production, it is still a rural hamlet of Fauquier County. Beverly's Mill and the Georgetown Cemetery also call Broad Run home.

Lakeland near Rectortown is the house where Col. John S. Mosby was shot during the Civil War. Not far from Rectortown is Rokeby Road, where Paul Mellon and his family once lived. His estate is just a few miles southeast of Upperville and includes the Upperville Airport.

The schoolhouse near Rectortown is where the Lake clan once met. Rectortown is located just north of Marshall along Country Road 710. Once in Rectortown, one can travel west to Delaplane, north to Route 50, and east toward Zulla Road. The area is well known for its beautiful large farms and estates. Brothers John, Luther, and Thomas Lake served in Mosby's Rangers.

Sumerduck is a small unincorporated community in southern Fauquier that is known for its rural lifestyle. It is equidistant between Fredericksburg, Culpeper, and Warrenton. Colloquially referred to as "the Duck," this community is the home of the Sumerduck drag way. According to Sumerduck Trading Company, hunting, four-wheeling, and metal detecting are the most popular activities in this area; the latter is due to its proximity to major conflicts during the American Civil War.

All the folks in

Catlett

Send sincerest greetings

2107

Catlett is another small unincorporated community located just west of the Prince William County line. Catlett was a former rail stop on the Orange and Alexandria Railroad and is still quite rural for being approximately 45 miles from Washington, D.C. The area surrounding Catlett was the site of many raids on the railroad during the Civil War.

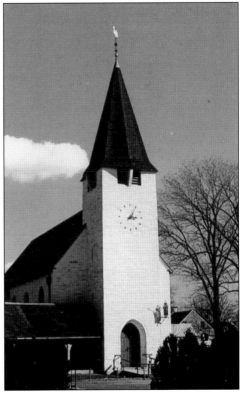

Trinity Episcopal Church, located on Route 50 in Upperville, is a well-known local landmark. U.S. Route 50 is known throughout Virginia as the John Mosby Highway; however, some sections of it are referred to as the Lee-Jackson Highway. Route 50 is steeped in history as a travel way. Native Americans first created it as they followed seasonally migrating game from the Potomac River to the Shenandoah Valley.

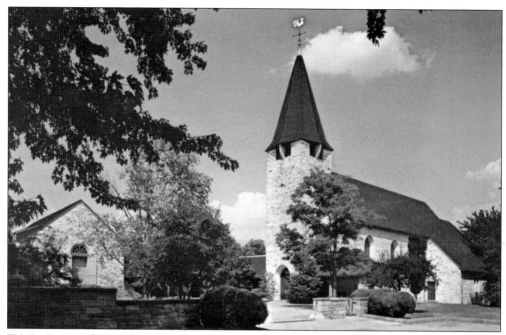

Trinity Episcopal Church was the gift of Paul and Rachel "Bunny" Mellon and was built in 1951, while the first service was not held until 1960. The fabric of the building is native sandstone, and men of the local countryside and surrounding area did the construction.

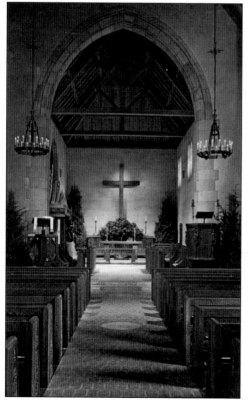

The interior of Trinity Episcopal Church in Upperville shows the beautiful architectural details of this traditional structure. Across the street from the Episcopal church is a white plastered home known as the Gulick House. This home dates back to 1830 and was originally the home of Dr. and Mrs. William Conrad. Mrs. Conrad is said to be the first owner in Upperville to concentrate on landscaping. Legend has it that she was the first person to bring a boxwood to the area.

The 1763 Inn is a charming country inn and restaurant at the foothills of the Blue Ridge Mountains in Virginia's hunt country. It is located 2 miles from Upperville on Route 50. Today this property is known as the Blackthorne Inn, an elegant and relaxed home-away-from-home for a weekend or midweek stay or for a longer getaway. Along Route 50 in Upperville, a series of road improvement projects has recently been completed to help travelers passing through the quaint village.

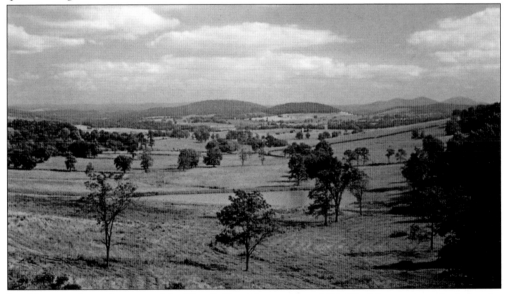

Looking east from the crest of the Blue Ridge Mountains at U.S. 50, this panorama includes the piedmont valley and Bull Run Mountains. This passageway was the scene of many of the Civil War raids by the "Grey Ghost" of the Confederacy. This card is referred to as the "View from Ashby's Gap." Further beyond these lands, east of Fauquier, is an ever-increasing urban population that is fueled by the demand for business around the Washington metropolitan area.

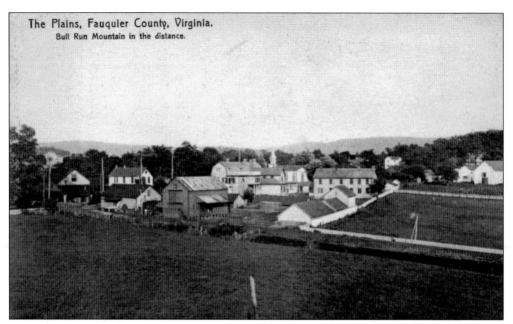

The Plains, Fauquier County, Virginia.
Bull Run Mountain in the distance.

The Plains is one of three towns in Fauquier County. The Plains is centered on Virginia Route 55 (John Marshall Highway) and Virginia Route 245 (Old Tavern Road). At the 2000 Census, just 266 people called The Plains home. However, The Plains is home to Great Meadow, a large open-air and open-field facility that hosts several large events throughout the year, including the Virginia Gold Cup steeplechase race.

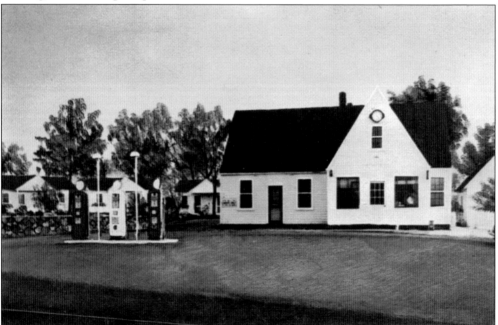

Ashby's Tavern and Tourist Court in Paris on U.S. 50 and Highway 17 was known for its completely modern tourist cottages, Texaco service station, good food, and merchandise. Gen. Turner Ashby was the second son of Col. Turner Ashby and was conspicuous in the first prelude to the Civil War, the John Brown Raid.

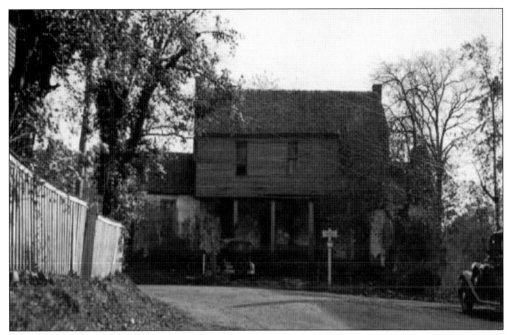

One of the earliest known ordinaries in Fauquier County was Ashby's Tavern in Paris. Here George Washington noted in his diary that he had arrived at "Captain Ashby's" on March 9, 1769. The area has many historical ties to George Washington. In his youth, Washington worked as a surveyor and acquired what would become invaluable knowledge of the terrain around his native colony of Virginia.

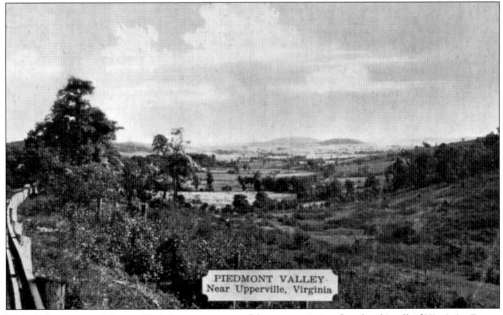

The piedmont near Upperville is home to some of the most pristine farmland in all of Virginia. Farms such as Llangollen, Lazy Lane, and Ayrshire still dot the landscape with horses, cattle, and agricultural production. Within recent years, the piedmont has seen a growth of new farms springing up that are producing products for sale at local farmers markets and other retail establishments.

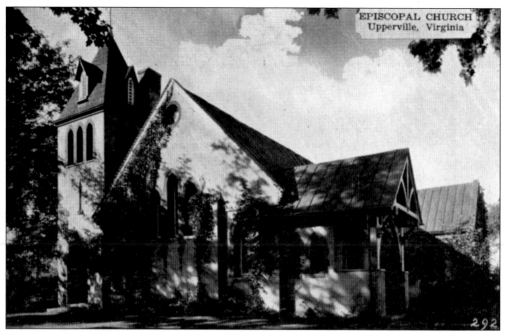

Shown here is the backside of Trinity Episcopal Church in Upperville. The Upperville Historic District was listed in the National Register of Historic Places in October 1972. Not far from the Episcopal church is the Carr House, built in 1796 by Josephine Carr. It is a long, white-plastered stone house directly on Route 50 and is known for having an unusual corner fireplace in the original dining room. Today the Carr House is known as the Hunter's Head Tavern.

This shows the Flying Circus Aerodrome in Bealeton, which is flown on every Sunday from May through October. Bealeton has grown tremendously in the last several years and is now known to many as a commercial hub of activity in the southern part of Fauquier County. Bealeton is located around the crossroads of U.S. 28 and 17 and is home to several schools, including Liberty High School, which opened in 1994.

Pictured is a farm scene from Remington. Remington is another one of Fauquier County's three incorporated towns. It lies in the southern part of the county, just a few miles from the boarder with Culpeper County. Today, the Remington Town Hall is located in the old State Bank of Remington building. The state bank opened on Main Street in 1913 but moved to a much larger facility in 1959.

This picture taken in the fall of 1966 shows the Southern First Mikado as it passes a farmhouse near Markham during the National Railway Historical Society trip over the Southern Manassas Branch. Markham is another small unincorporated community in Fauquier County, along State Route 55 and off Interstate 66. It is home to the Naked Mountain Vineyard and has its own post office and zip code.

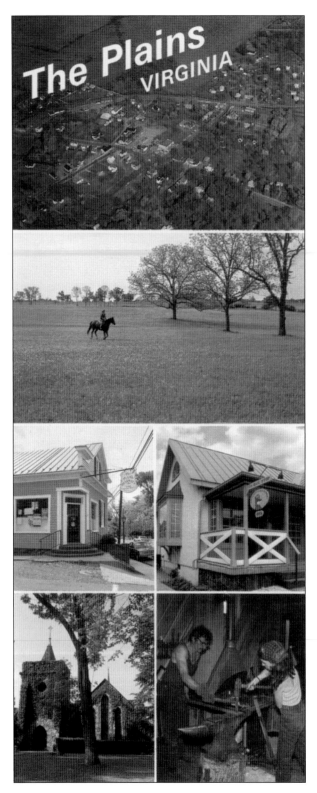

Since the opening on Interstate 66, The Plains, located on Route 245 between Middleburg and Warrenton, has grown to be a beautiful and lively village center in the heart of the piedmont's farm and horse country. Great Meadow, a 500-acre stretch of rolling farmland just south of The Plains, hosts horse and field events and serves as home to the classic Virginia Gold Cup steeplechase meeting.

Five

Hunt and
Horse Country

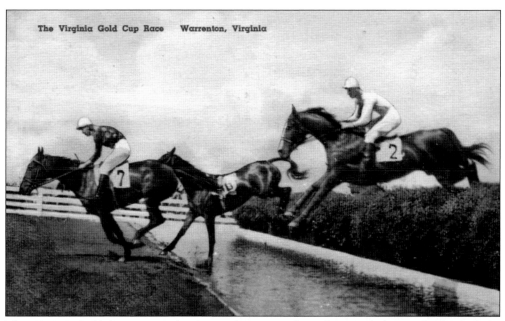

The Virginia Gold Cup is a grand spring tradition as well as a fixture on the social calendar. The 85th running of the world-famous Virginia Gold Cup steeplechase race took place on Saturday, May 1, 2010, at Great Meadow in The Plains. Run in Fauquier County since 1922 and attended by over 50,000 spectators, this race is one of the largest and most popular sporting events in the greater Washington metropolitan area.

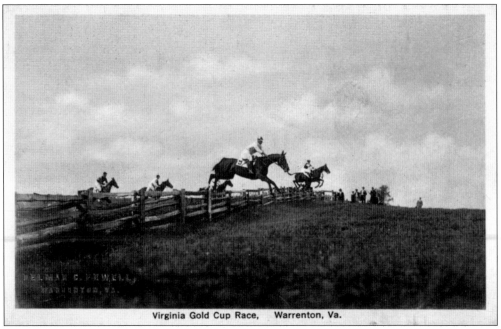

Virginia Gold Cup Race, Warrenton, Va.

Today the Virginia Gold Cup race features six hurdle and timber horse races; Jack Russell terrier races; tent, tailgate, and hat contests; and a wide variety of vendor booths for shopping. Ticket sales benefit the Great Meadow Foundation, a nonprofit organization dedicated to the preservation of Great Meadow's open space for community access.

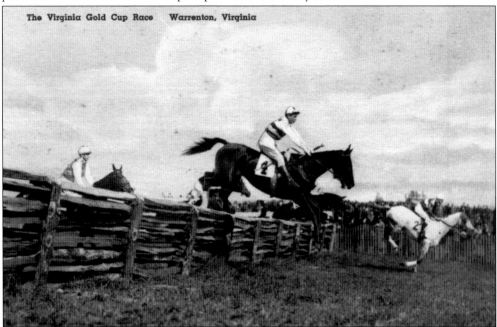

The Virginia Gold Cup Race Warrenton, Virginia

One becomes a member of the Virginia Gold Cup Association by purchasing a ticket to one of the races. At the time of ticket purchase, the new member is also placed on the mailing list, and there are no annual dues. Offices for the Virginia Gold Cup Association are located on Main Street in Old Town Warrenton.

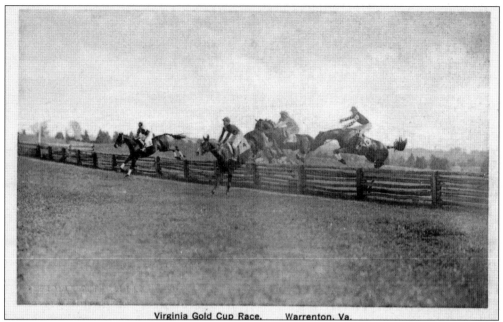

Virginia Gold Cup Race. Warrenton. Va.

According to the Virginia Gold Cup Race Web site, steeplechasing in Virginia has been a way of life since early colonial times; the horse was the primary way of transportation for farming and war. George Washington and Thomas Jefferson met in sporting competition over fences. Organized steeplechase races have run in Fauquier County since 1844 and originally started at White Sulphur Springs, then a fashionable spa.

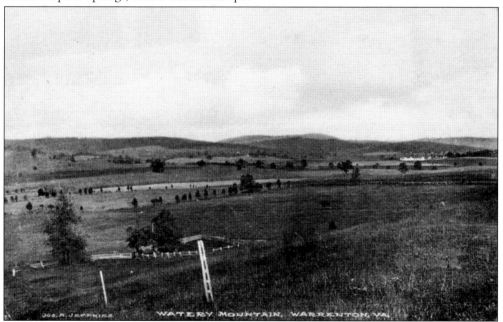

Watery Mountain, barely outside the incorporated limits of Warrenton, Virginia, is located just north along Route 17 in Fauquier County. Watery Mountain's elevation is about 1,129 feet above sea level, and it offers some of the best scenes surrounding Warrenton. Formal hiking trails do exist on Watery Mountain for the outdoor enthusiast.

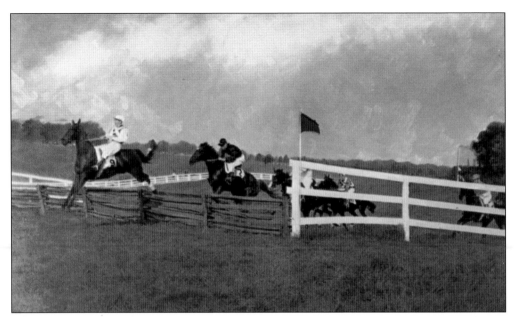

On April 3, 1922, eight sportsmen met at the Fauquier Club in Warrenton and decided to organize a 4-mile horse race between flags over the natural walls and fences of the nearby hunting countryside. Pledging $1,000 to purchase a trophy for the winning owner, they ruled that it be kept permanently by the first owner to win the race three times, not necessarily in consecutive years nor with the same horse. Just 34 days later, they held the first Virginia Gold Cup race.

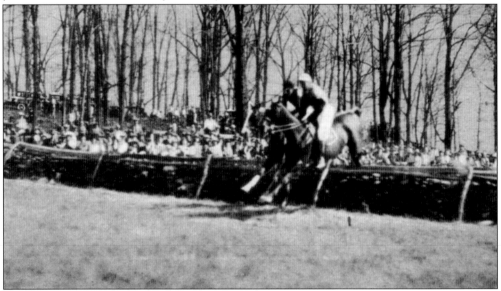

In 1924, the race moved to a new course, Broadview Farm near Warrenton, and it was run for the first time under national steeplechasing rules. With only a few interruptions during World War II, it has run each year since. The 1984 race was the last to be run at Broadview. In 1982, a news executive and philanthropist, Arthur W. (Nick) Arundel, found a 500-acre site on an abandoned farm about 10 miles north near The Plains. Arundel purchased the property, then scheduled by its owner to become a huge housing development, for a new racecourse and to preserve the land in open space.

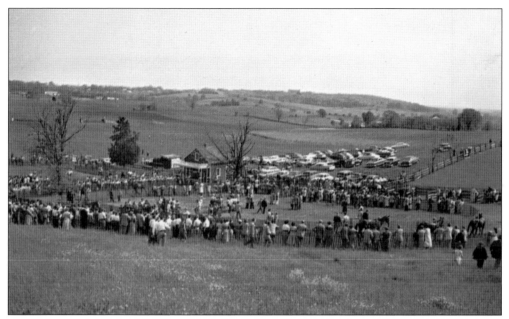

In 1985, after several test gallops, the Gold Cup moved after 50 years at Broadview to the new racecourse for its 60th running. Thus a new era of the Gold Cup Classic began. Great Meadow is quite different from the old Broadview course. At the old course, cattle grazed on the course 11 months a year, as was typical of that era's race meetings. The new Great Meadow course provides ideal conditions for horses and spectators alike, and its fences are higher than those of the old Broadview course.

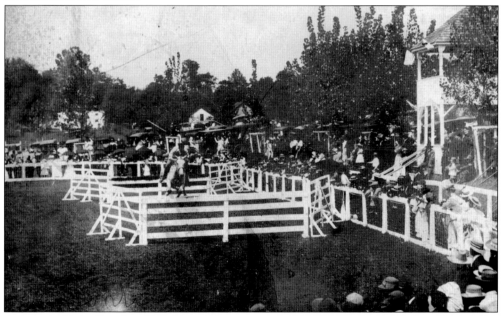

The Warrenton Horse Show is a staple of life in the piedmont and is located along the Shirley Avenue bypass in Old Town. Warrenton is home to varying facilities. Historical staples, such as the horse grounds, are becoming more and more of a contrast to the new development around town, such as the Warrenton Aquatic and Recreation Facility.

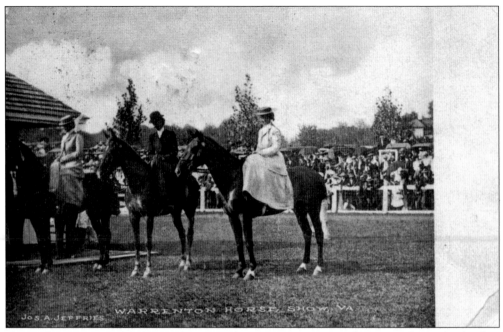

Shown here are several ladies on horses at the Warrenton Horse Show. On the back, the date stamp marks the card being mailed in 1910. The horse grounds are situated just beyond a lovely neighborhood on the southern edge of Old Town. They are near the intersection of West and East Shirley Avenues. In its heyday, Neptune Lodge backed up perfectly to the fairgrounds for easy access.

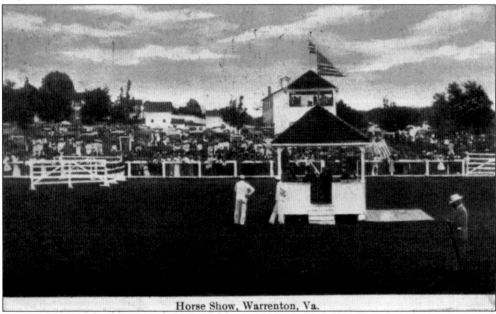

Horse Show, Warrenton, Va.

Seen here is a photograph of the Warrenton Horse Show. In 1899, C. W. Smith organized the Warrenton Horse Show Association, a corporation of approximately 100 citizens around the community. Smith was the manager and treasurer from the beginning of the organization, which was successful from the very start.

Here is the Virginia Gold Cup trophy from when the races were in Warrenton. While the races are still run near Old Tavern, Gold Cup in Warrenton now references a new housing development. Catherine the Great of Russia presented the original trophy in the 18th century.

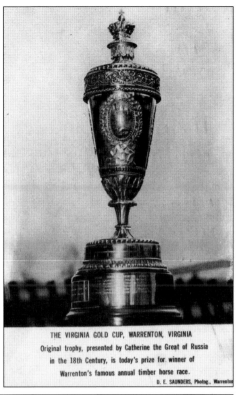

THE VIRGINIA GOLD CUP, WARRENTON, VIRGINIA
Original trophy, presented by Catherine the Great of Russia in the 18th Century, is today's prize for winner of Warrenton's famous annual timber horse race.
D. E. SAUNDERS, Photog., Warrenton

Events such as the Upperville Colt and Horse Show and the Virginia Gold Cup race add to the allure of Fauquier County and the area surrounding Warrenton. By the 1930s, Fauquier and parts of neighboring Loudoun County were well established as horse country. People soon began selecting the region for second homes because of the beautiful landscapes, longer hunting seasons, and real estate bargains.

Warrenton and the surrounding Fauquier County are both still known for being in the heart of Virginia's horse country. It would be unlikely for a resident or visitor to venture out into the countryside and not see a horse farm. According to the Virginia Department of Agriculture and Consumer Services, Fauquier County has the most expensive horses in the commonwealth. Fauquier is also home to the second-largest county horse population in Virginia.

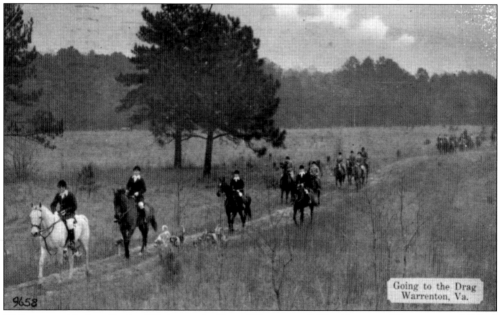

This postcard is described as "Going to the Drag, Warrenton." The Casanova Hunt was established in 1909 and officially recognized 1910. The hunt country is located in central and eastern Fauquier County as well as parts of southeast Culpeper County, northeast Orange County, northeast Spotsylvania County, and western Stafford County. It is a mixture of open grass and woodlands. Fences are mostly timber and coops.

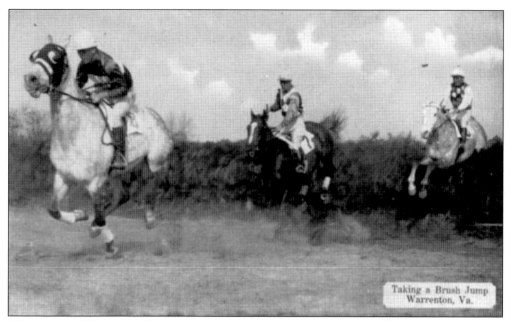

This postcard is labeled as "Taking a Brush Jump, Warrenton, Va." Today horse riding and racing are still extremely prominent in and around Fauquier County.

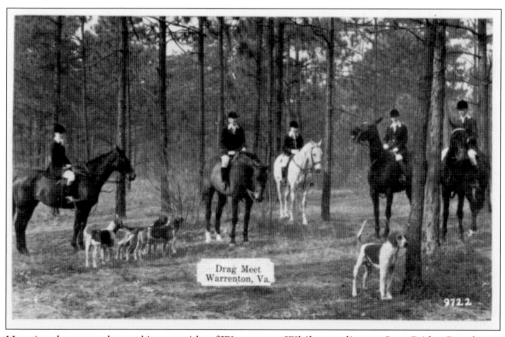

Here is a drag meet located just outside of Warrenton. While traveling on Lees Ridge Road near Whitney State Forest, one can see a hunt stand off to the distance on the North Wales property. Before the Civil War, one of the most prominent sportsmen was Capt. Elisa Edmonds. Edmonds's hounds were famous for their breeding and beauty, being snow white with black spots.

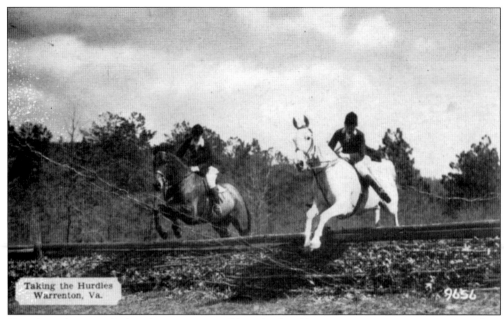

Taking the Hurdles
Warrenton, Va.

9656

Here is a photograph showing someone taking the hurdles in Warrenton. In 1961, Jacqueline Kennedy (then first lady) attended the Piedmont Point-to-Point Races. President Kennedy's only appearance at a hunt country sporting event was in April 1961, while he was vacationing at Glen Ora, near Middleburg. They both attended mass at the Middleburg Community Center just outside Fauquier County that same weekend.

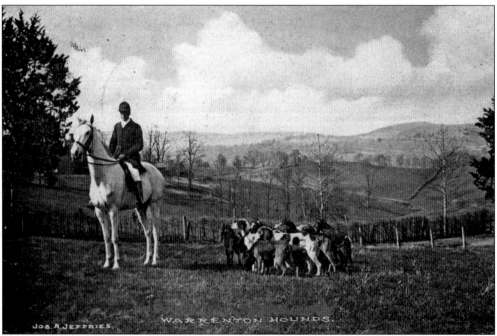

Organized in 1840 by Upperville landowner Richard Henry Dulany, the Piedmont Foxhounds was the nation's first formal hunt club. The Civil War temporarily suspended the sport of fox hunting, as packs of hounds were sold off due to more pressing priorities.

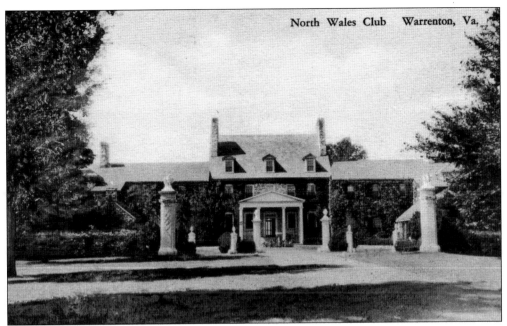

The North Wales Club is a 4,200-acre estate that sits on Springs Road approximately 3 miles southwest of Old Town Warrenton. It has been the site of heated debate between area preservationists and developers. In the mid-1970s, citizens rallied against a developer seeking to turn the land into a large subdivision. In the 1920s and 1930s, North Wales served as a private club. In 1941, Walter Chrysler purchased it for $175,000. Today it remains a mixed agricultural operations farm.

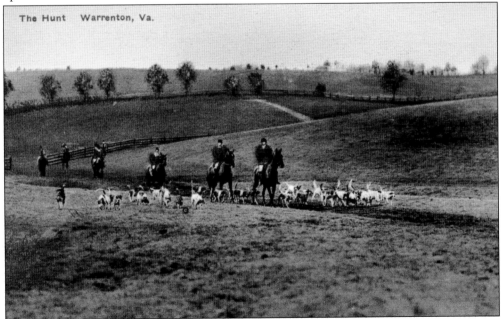

The sport of fox hunting enjoyed a limited revival in the 1870s and 1880s, when a small migration of British farmers and horse breeders reengaged in the sport. However, fox hunting has always been just one of the equine-orientated sports in the piedmont and Fauquier County.

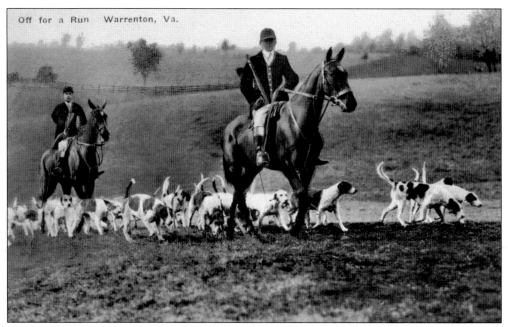

Pictured are sportsmen off for a run near Warrenton. While traveling south from Warrenton on Springs Road, a sign for the Warrenton Hunt is visible.

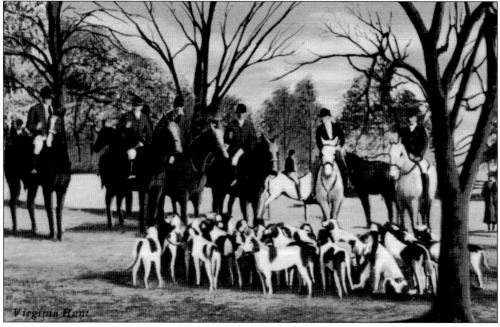

Shown here are the huntsmen on their horses with hounds at their sides. Every spring in and around Fauquier County is the Hunt Country Stable Tour. The 51st annual event took place in May 2010. This is a self-driven tour of stables in Middleburg and Upperville presented by Trinity Episcopal Church.

Six

COUNTRY SCENES

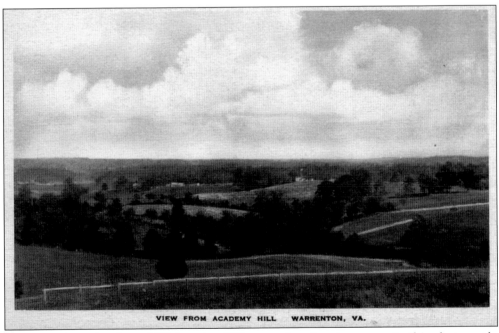

VIEW FROM ACADEMY HILL WARRENTON, VA.

The view from Academy Hill is quite different today than it appears in this photograph. Today one would be hard-pressed to see a stitch of farmland. Instead a growing number of developments and suburban housing neighborhoods can be seen. Tracks such as Colony Court, Canon Way, and White's Mill dot the landscape, making Warrenton another one of D.C.'s bedroom communities.

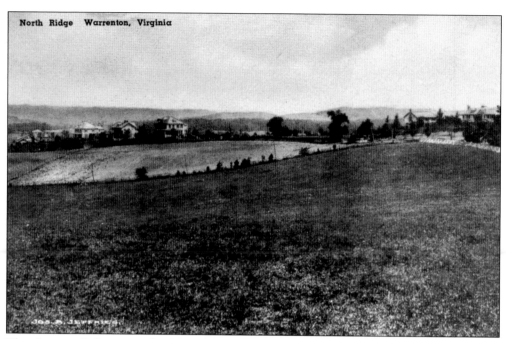

The photograph shows North Ridge in Warrenton, Virginia. To some, the houses and buildings shown here appear to be eerily similar to those of the current Winchester Street. The Stuyvesant School appears to be at the far right of the photograph.

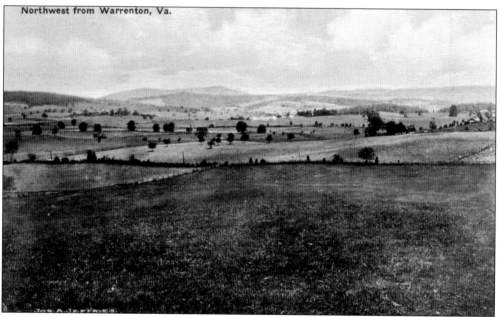

A northwest view from Warrenton shows the fertile piedmont farmlands. Today the Route 17 corridor, leading northwest up to Interstate 66 and the Marshall area, is still almost completely open space and farmland. This is a stark contrast to those heading northeast up the Route 29 corridor to Interstate 66 and the Gainesville area. Gainesville has been the recent home of much development in the western part of Prince William County.

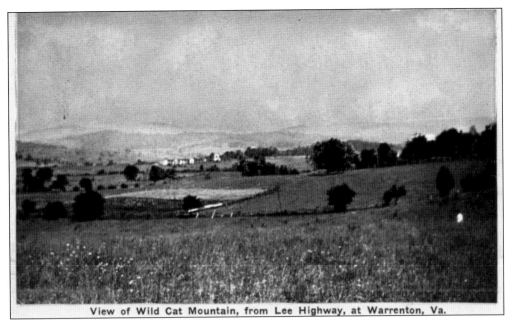

View of Wild Cat Mountain, from Lee Highway, at Warrenton, Va.

The view of Wildcat Mountain from Lee Highway at Warrenton shows a beautiful piedmont country scene of well-maintained farmland and pastures, with rolling hills to the distance. Wildcat Mountain is located just north of Warrenton, off Route 17 heading toward Marshall. Thanks to a donation from the Arundel family, Wildcat Mountain became the Nature Conservancy's very first preserve in Virginia.

This shows a typical piedmont scene near Warrenton. On November 11, 1993, residents of the piedmont, including Fauquier County and surrounding regions, woke up to news that the Disney Company proposed to develop a $650-million historical-theme park nearby in western Prince William County. This proposal initiated a high-profile battle that played out across the United States. However, 11 months after its initial proposal, Disney withdrew it, citing the success of the opposition.

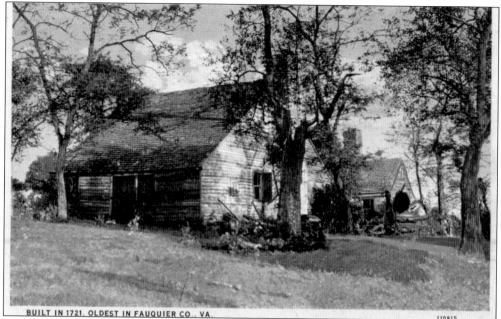

Pictured here is an old house and structure built in 1721 in Fauquier County. This old house is said to have been built by William Russell and located west of Elk Run. It was constructed of wide beaded boards and designed in the saltbox style, as a five-room dwelling with many similarities to those early Williamsburg homes. Fauquier did not become an official county until 1759, roughly 40 years after its construction.

Scene near Warrenton, Va.

Here is a scene near Warrenton, most likely just outside town limits. Today Fauquier County is made up of five districts: the Center, Lee, Scott, Cedar Run, and Marshall Districts. A supervisor is elected every four years to represent these districts on the board of supervisors. These individuals have ruled on many important decisions that have shaped Fauquier to make it what it is today.

Road View, near Warrenton, Va.

A road view near Warrenton shows a passageway out to the countryside of Fauquier. Notice the staked stone walls to the left and right and farm fencing. These are still staples in many parts of the county.

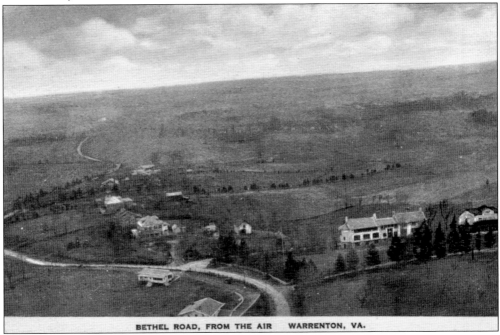

BETHEL ROAD, FROM THE AIR WARRENTON, VA.

This photograph shows a picture of Bethel Road from the air in Warrenton. This appears to be part of Winchester Street in Old Town near the corner of King Street. It also appears to show part of the old Stuyvesant School, as well as a few of the old houses that still reside along Winchester Street.

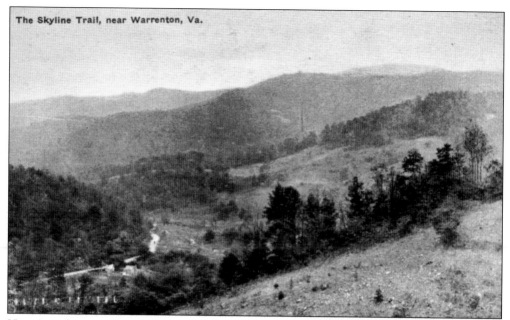

The Skyline Trail, near Warrenton, Va.

Here is a photograph showing the Skyline Trail near Warrenton. In the northern region of Fauquier County, just an hour's drive from Washington, D.C., is Sky Meadows State Park. This park offers a peaceful getaway on the eastern side of the Blue Ridge Mountains. With rolling pastures and woodlands, the park boasts beautiful vistas of the foothills and access to the Appalachian Trail.

View near Warrenton, Va.

Shown here is a view of pasture and farmland with the rolling hills of Fauquier County and the piedmont. About 18 miles from Warrenton, in the western part of Fauquier, is the unincorporated community of Hume. Hume was known as Barbee's Crossroads in the mid-1800s after Joseph Barbee, who had leased the land from Denny Fairfax in 1787.

Here is a typical road scene found in Fauquier County during the early 1900s. Although it is difficult to tell the specific location, it appears to possibly be part of the current Lees Ridge Road, just outside Warrenton. Lees Ridge Road provides a spectacular vista that overlooks Western Fauquier County and the adjourning piedmont. One can see Springs Valley and the nearby Shenandoah Mountains.

The gateway to Warrenton on Lee Highway shows some of the earliest roads leading country residents to town. Today Lee Highway is U.S. 29, running almost the entire commonwealth, primarily from north to south.

COUNTRY SCENE NEAR WARRENTON, VA.

This card shows a country scene near Warrenton. The back of the postcard is stamped 1915, and it was sent to Lewis Payne in Arlington.

SCENE NEAR WARRENTON, VA.

This scene near Warrenton shows views that can be seen from many of the country roads in Fauquier. Animals are grazing in the pasture in this postcard. Even with a dramatically smaller dairy industry in Northern Virginia, Fauquier is still home to a number of dairy farms along the Route 28 corridor. With rail near by, this historically allowed an easy distribution of milk and other diary products to people across the country.

View from View Tree, looking towards Warrenton, Va.

The scene from View Tree, located just west of Warrenton, is looking toward town. According to *The Diary of Court House Square*, the Warrenton Training Center took over View Tree Mountain in 1955. In 1952, a flying saucer was reportedly seen in town and eventually disappeared over View Tree Mountain.

WARRENTON, VA.

A man is shown here in a creek in Warrenton. Although not known for its waters, a number of small ponds and lakes can be found in and around Warrenton. Airlie Lake, a few miles north of Warrenton, has a stunning waterfall when flowing that can be seen from Airlie Road, Route 605.

Dear Cousin, I am glad you got home safe [...] all well. We are all well except mama. Papa have cold [...]

Here is a bridge across the Rappahannock River in Kelly's Ford. Today Kelly's Ford is the only crossing on the river between Fredericksburg and Remington in southern Fauquier County. In early times, Kelly's Ford was a major crossing point on the Rappahannock River and was the site of a Civil War battle for control of the river ford.

PIEDMONT

The Piedmont province lies between the eastern slope of the Blue Ridge and the Coastal Plain, 70 miles away. This is a gently rolling land surface with scattered small mountains that are remnants of a vast mountain range long since eroded away.

The piedmont overlook gives hikers a bird's-eye view of what the rolling hills and farmlands look like from the sky. Airplanes leaving the Fauquier County Airport can often be seen touring the countryside in the summer months. Photographer Kenneth Garrett makes his home in Broad Run and has taken many spectacular photographs of the Fauquier County countryside from the air.

Seven

THE WARRENTON BYPASS

The Warrenton Motor Lodge was a modern facility located on 100 quiet acres. Each room had 50-mile panoramic views of the Blue Ridge Mountains. At the lodge there was a snack bar and formal dining room.

Chicken in the Rough was known for is its fried chicken and its slogan, "every bite a tender delight." This illustration by Beverly Osborn also mentions their shoestring potatoes, jug honey, and hot buttered rolls. The back of the card talks about a contest with a $100 prize awarded to the first person to eat at 25 or more locations of Chicken in the Rough. This contest was also described on the place mats and picnic boxes.

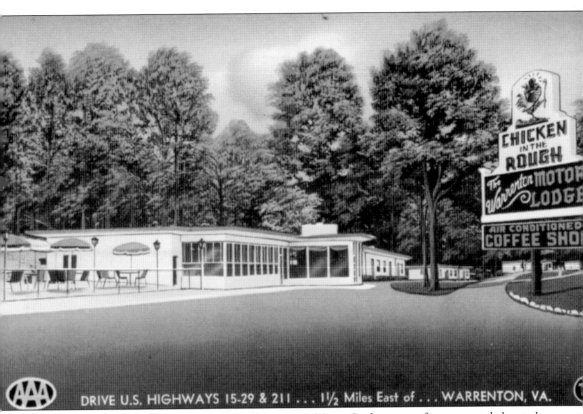

DRIVE U.S. HIGHWAYS 15-29 & 211 ... 1½ Miles East of ... WARRENTON, VA.

Chicken in the Rough was part of the Warrenton Motor Lodge, one of many motels located in and around the Warrenton area. As described on the front, the Warrenton Motor Lodge was located 1.5 miles east of Warrenton. The owner was Barney Harris, a prominent townsman.

The Sycamore Hill modern-family cottages were on the Route 29-211 bypass in Warrenton. The Sycamore Hill Motor Court and Restaurant is no longer in business. Traveling throughout the area, cottages from the mid-1900s welcoming visitors can still be seen from the road, although most have closed.

The Fauquier Motel and Restaurant is situated on the right while traveling south on Highway 15-17-29 and is 5 miles south of Warrenton. The Fauquier Motel is still a fixture today, hosting short stays for residents and overnight comforts for passersby. Currently, U.S. Route 29 is going through an extensive study on how best to preserve the divided highway as an alternative transportation route to the neighboring interstates.

The Rip Van Winkle Motel, built in 1954, is located on the Warrenton bypass. At its heyday, it included 28 modern units, which was expanded from its original 16 units. Each unit had air conditioning and a color television with access to a swimming pool and restaurants near by.

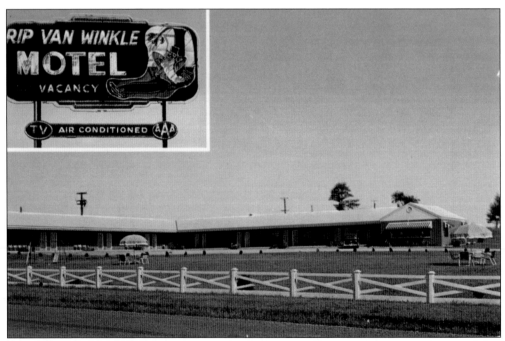

Situated also on the Warrenton bypass, "The Rip" can still be seen today. Some have said that the history of Fauquier County and Warrenton can be one of roads in a love/hate relationship. Although the convergence of roads literally put Warrenton on the map, the development of roads and modern infrastructure has and continues to threaten Fauquier's beauty and history.

Johnson's Motel was built in 1953 and is located 5 miles south of Warrenton. It is on the left while traveling south on Highway 15-17-29. Today many drivers and passengers use this highway to commute north up to Interstate 66 or south to Interstate 95. U.S. 29 connects Gainesville in the north to Danville in the south.

Shown here is Johnson's Motel, attracting travelers with its sign that says Johnson's has "good food and air-conditioned rooms."

The Jefferson Motel was built in 1952 and is located on the Warrenton bypass, not far from many of the other motels and service areas found today. Even with the protection of Old Town Warrenton, the town itself has experienced some major changes, such as the commercial-district bypass and the eastern limited-access bypass. Residential development along the outskirts of Warrenton has helped surround Old Town with suburban sprawl.

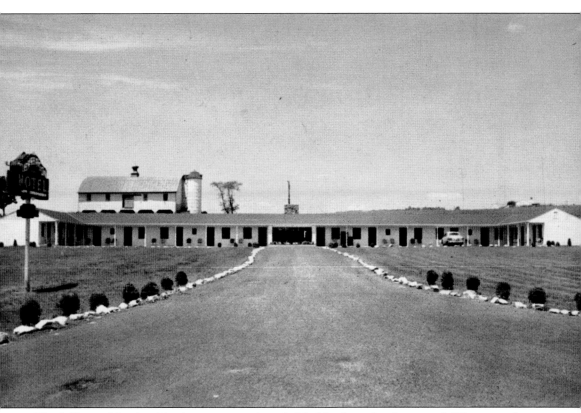

The Jefferson Motel, with a large country barn behind it, shows just how much Warrenton has changed. Today this barn is long-gone, replaced with homes and suburban streets. Streets such as Rappahannock, Blue Ridge, and Piedmont all can be found behind the Jefferson Motel.

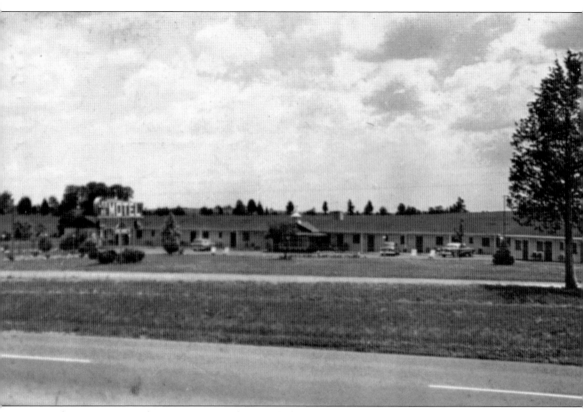

The Lee-Hi Motel was a nice stop for people looking to take a break while traveling. Many of the old motels along the road in Northern Virginia and the piedmont have been replaced because of growth. Postcards today might show the new Wegmans or Gainesville shopping plaza. The small historic village of Buckland, near where the old Lee-Hi stood, may also be another one of these postcards.

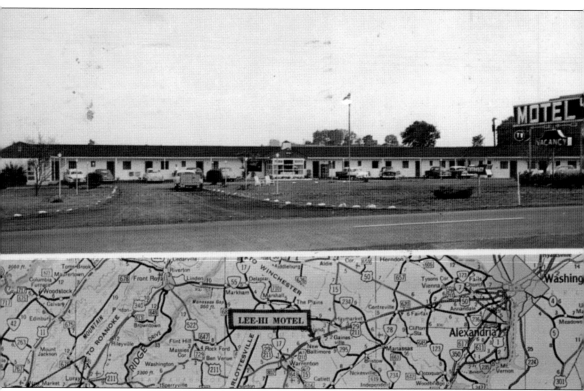

The Lee-Hi Motel was 6 miles northeast of Warrenton on Highway 15-29-211, close to what is now known as the New Baltimore area. Today New Baltimore is home to the southern end of the Route 29 development surrounding Gainesville. In 2006, with Fauquier County's designation of service districts, the area officially considered to be New Baltimore expanded significantly.

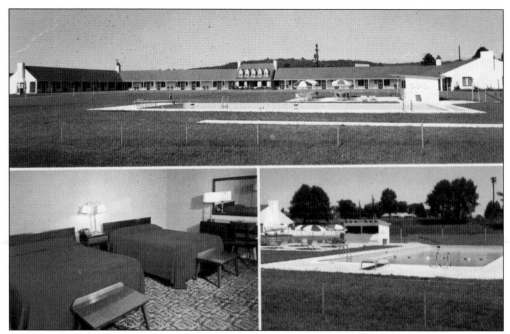

The Cavalier Inn, located on the Warrenton bypass, had 50 modern rooms as well as a 75-foot swimming pool out front. Today the swimming pool no longer exists, and out front is McMahon's Irish Pub and Restaurant. The Cavalier has also been renamed the Cheswick.

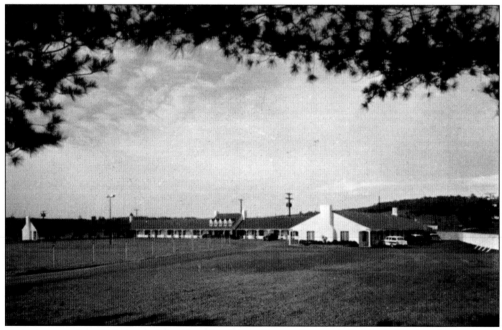

Here is an updated picture of the Cavalier Inn without the pool. Behind the Cavalier today is a tranquil neighborhood built in the mid-20th century, as Northern Virginia was just starting to see development. The back of the postcard lists a four-digit phone number for the inn rather than today's seven-digit number.

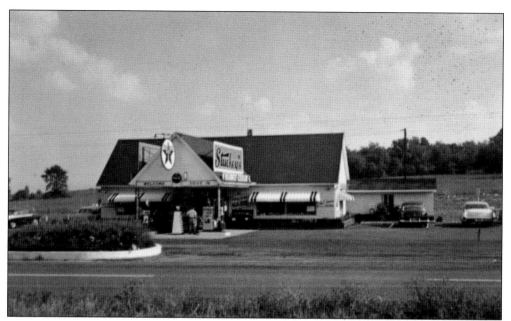

Stuckey's Pecan Shoppe was located 5 miles east of Warrenton in New Baltimore. Although New Baltimore has been an unincorporated community since the early 19th century, it has just recently become a suburban community because of its easy access to Washington, D.C. As a result, many people who live in New Baltimore commute into D.C. It is just 2 miles southwest of the border of Prince William County.

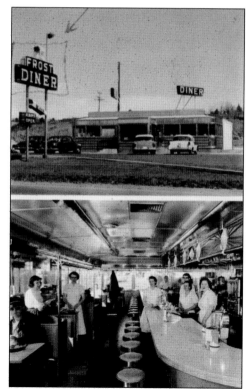

Frost Diner, located on the Warrenton bypass, has been a mainstay for late-night diners and early risers. During the 1950s, the Warrenton bypass was created because of problems with traffic and congestion going directly through Old Town. Construction of this bypass helped usher many Old Town businesses to the new shopping centers that were built.

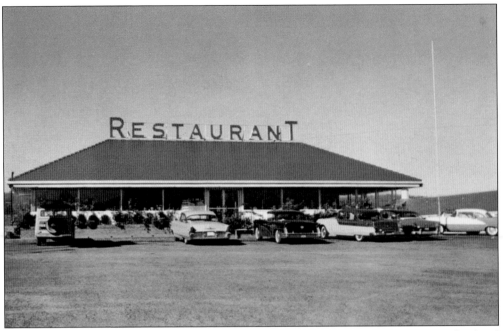

A&B Restaurant, located on the Warrenton bypass, was known for specializing in seafood and other regional foods, such as Smithfield ham. It marketed itself as the best food in Northern Virginia and sat at the corner of Waterloo Pike and the bypass. Not far from where A&B once stood, across the street is the Frost Diner.

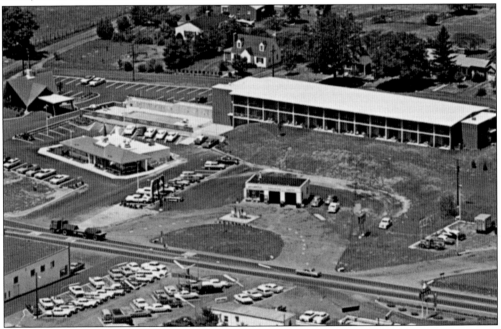

Howard Johnson's Motor Lodge and Restaurant is located on the Warrenton bypass, Highway 15-29-211. It's not hard to recognize where this is today because of its striking similarities. The Howard Johnson is still in business, and the restaurant is as well. Today it is known as Foster's Grille. A few other businesses would be in today's overhead shot, including Burger King.

Colonial Inn
Routes 15 and 211, Warrenton By-Pass
Warrenton, Va.

38374

Colonial Inn, located on the Warrenton bypass, was known for its luxurious accommodations. The building still stands today but is known as the offices for Cash Point Car Title Loans. Today new hotels such as the Holiday Inn Express and Hampton Inn provide overnight accommodations for folks looking to spend the night. As an alternative to the hotel, the Black Horse Inn on Meetze Road offers old charm and feel, which is often hard to find today.

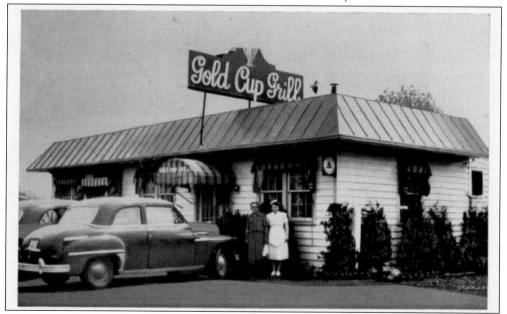

The Gold Cup Grill, once situated on the Warrenton bypass, has been torn down and replaced with fast-food establishments. One tribute still left to horse country is Ben and Mary's Steakhouse, just a few miles north of the bypass on Route 17. Ben and Mary's Steakhouse is home to a fabulous filet mignon, prime rib, and chops. It can seat up to 70 people at one time.

STOP AT THE BLUE PARROT RESTAURANT

GOOD FOOD

WARRENTON, VA. BY-PASS 211 AND 15

The Blue Parrot Restaurant, famous for its Southern food and hospitality, was located on the Warrenton bypass. Even with a bypass established around Old Town, the area soon became clogged with traffic, and alternatives were debated. In 1986, a new limited-access road was built to help ease commuters along the eastern boarder of Warrenton. People around Warrenton and Fauquier County now joke about taking the bypass "to bypass the bypass."

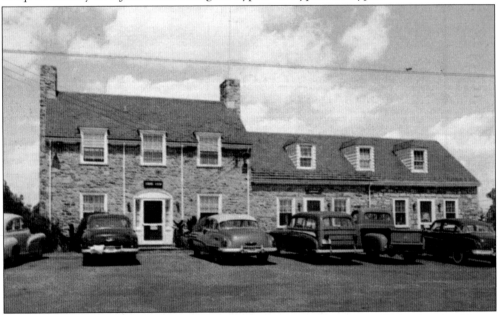

Shown here is the classic stone building of the Blue Parrot Restaurant, offering hunt and horse country food. The Blue Parrot has been replaced by places like Applebee's, Ruby Tuesday's, and Red Hot and Blue along the Warrenton bypass. In the spring of 2010, a bypass cutting along the western edge of Warrenton was being debated to help ease congestion and link travelers between Route 17 and Route 211.

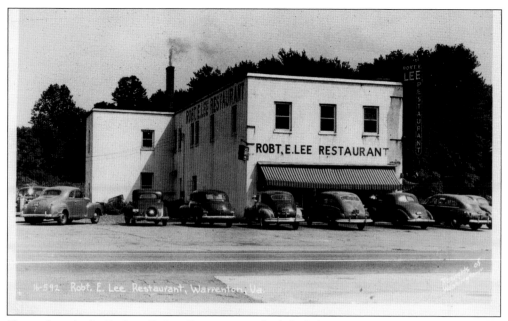

Shown here is the Robert E. Lee Restaurant, which had the restaurant on the first floor and rooms available to stay in on the second. Since being a restaurant, it has gone through a number of other changes and businesses. It was Browns Wood Stuff for many years and has recently become J&D Handyman. Across Waterloo Pike, in Rankins Waterloo Shopping Plaza, is Carousal Frozen Treats, serving ice cream throughout the warm summer months.

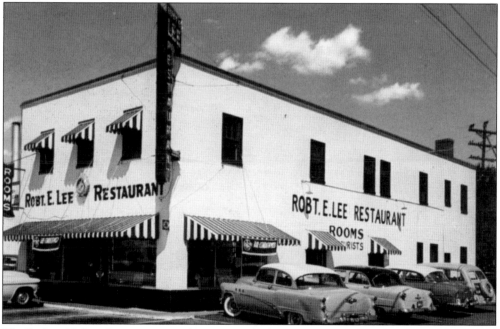

The Robert E. Lee Restaurant was known as "the house of good food" and was located on the Warrenton bypass. At the corner of Waterloo Pike and the bypass, it sat across the street from the Howard Johnson Motel. For many years, this building anchored a fabulous restaurant for people to enjoy while in Warrenton.

The Huntsman Restaurant, located at the junction of Routes 29 and 211, was known for its fresh beef and seafood and featured bluegrass and country music on Friday and Saturday nights. It was established in the same building as the former Robert E. Lee restaurant. These family-oriented establishments named after historical figures or events in the area are becoming harder and harder to find in Fauquier County.

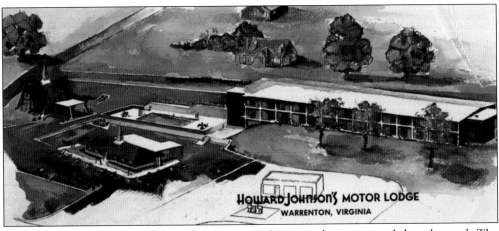

Since this picture of Howard Johnson's Motor Lodge was taken, not much has changed. The street behind the motel has added many more houses, and the names of the establishments out front are different, but the overall landscape is remarkably similar. The pool shown is still open as well. Rather than the gas station outlined in black and white, another restaurant has taken that spot.

BIBLIOGRAPHY

Census Bureau Home Page. www.census.gov (accessed April 10, 2010).

Day, A. G. *Sketches and Illustrations of Warrenton and Fauquier County*. Warrenton, VA: The Fauquier Democrat, 1908.

The Fauquier County Bicentennial Committee. *Fauquier County, Virginia 1759–1959*. Warrenton, VA: Virginia Publishing, 1959.

The Fauquier County Historical Society. *250 Years in Fauquier County—A Virginia Story*. Fairfax, VA: George Mason University Press, 2008.

———. *A Walking Tour of Warrenton Virginia*. Fairfax, VA: George Mason University Press, 1998.

The Fauquier County Department of Agricultural Development. www.fauquiercounty.gov/government/departments/agdev (accessed April 10, 2010).

Hunt Country Stable Tour 2010. www.huntcountrystabletour.org (accessed April 10, 2010).

Jones, Virgil Carrington. *Ranger Mosby*. Chapel Hill: University of North Carolina Press, 1944.

Moffett, Lee. *The Diary of Court House Square*. Stephens City, VA: Commercial Press, 1988.

Porter, Hope. *The Saga of North Wales*. Warrenton, VA: Citizens for Fauquier County, 2004.

Slater, Kitty. *The Hunt Country of America—Then and Now*. Upperville, VA: Virginia Reel, Inc., 1997.

Virginia Hunt Country @ The Old Habit. www.oldhabit.com/va_hunt (accessed April 10, 2010).

Warman, Joanne Browning, ed. *The Memorial Wall to Name the Fallen: Warrenton, Virginia Cemetery*. Warrenton, VA: The Fauquier Times-Democrat, 1998.

Welcome to the Virginia Gold Cup Races. www.vagoldcup.com (accessed April 10, 2010).

Williams, Kimberly Prothro. *A Pride of Place: Rural Residences of Fauquier County, Virginia*. Charlottesville: University of Virginia Press, 2003.

www.arcadiapublishing.com

Discover books about the town where you grew up, the cities where your friends and families live, the town where your parents met, or even that retirement spot you've been dreaming about. Our Web site provides history lovers with exclusive deals, advanced notification about new titles, e-mail alerts of author events, and much more.

MADE IN THE

Arcadia Publishing, the leading local history publisher in the United States, is committed to making history accessible and meaningful through publishing books that celebrate and preserve the heritage of America's people and places. Consistent with our mission to preserve history on a local level, this book was printed in South Carolina on American-made paper and manufactured entirely in the United States.

Find Your Place in History.